吴布雷兹
Wu, BLAZE

十年

O The Art of Blaze Wu

﹐○ 這個女孩很強

從一個書賣很爛的臭屁作家，到現在大家眼中的暢銷作家，我在出版上受了非常多人的幫助，這些人都是非常厲害的怪物。在他們的鼎力相助下，我不由自主科科科謙虛了起來。

現在這篇序要說的，就是一個怪物與我相遇的故事。

二〇〇五年，我寫作後第五年。

書才剛剛有些起色，我媽媽卻病了。

陪著我媽做化療，我在病床旁廢寢忘食地寫作，期待生命出現轉機。某天下午跟我無關的第一屆奇幻藝術獎插畫類（白虎獎）結果出爐，我上了網站看了許多得獎的作品，打發時間。

當然有很多很棒的作品，但我的眼睛始終移不開一張擁有美妙水藍色、兩個魚族少女坐在岸邊笑看海的畫。畫很有靈氣，卻又充滿了大器。

看了一下名次，不是首獎？佳作！

我的天，這不是有潛力。

而是──這個嚴重被低估的傢伙，現在就是個高手！

抱著非常害怕被別人捷足先登的惶恐心態，我立刻打了兩通電話，請兩間跟我合作的出版社務必跟作畫的主人聯繫上，將來看看能不能請他幫我畫封面、畫插畫。

後來才知道那個他，原來是個她，有個很有殺氣的名字「Blaze」（猛烈的火焰），跟我的筆名九把刀還真是有一點搭。後來得知 Blaze 是我的忠實讀者，表面上她很開心可以跟我合作，但我簡直是超爽的。

Blaze 不僅畫功很強，而且擅長布局，畫面的構成有非常豐富的巧思，她喜歡看我的小說，對我的故事有愛，所以畫出來的不管是封面還是插畫，都絕非「應付出版社編輯的需求」，而是充滿了亟欲與我的故事呼應的熱情。

Blaze 很強。

而且將越來越強。

因為 Blaze 的強，強在她沒有放棄變強的機會。

絕不侷限，她幾乎勇於嘗試所有的類型，隨著永無休止的接案地獄，畫風越來越有延展性，建立起多元的「Blaze 氣味」。這種「絕不侷限」的自我挑戰，不可能會有「不斷重複自己」要來得容易「成功」，但……我還是想說：每個人推到上帝前面的籌碼不一樣，將來回收的籌碼也不會一樣。

有一件事，Blaze 還不知道。

有些時候，妳不會知道，自己不經意就鼓舞了另一個人。

去年年初我因為某學生抄襲我的小說得了文學獎還賣乖的雞巴事件，上了報紙頭條，徹底的被污衊讓我覺得很度爛，還有幾個小人逮到機會群起攻之，害我哈棒傳奇二寫到一半中斷。幹。那時我連續好幾天都在我阿宅小小的內心世界裡引爆核彈，想將地球舉起來過肩摔。

我忿忿不平的時間，比大家知道的都還要久，久很多很多。

某一天我在網路上看到 Blaze 接受一群學生的訪談影片，影片中，Blaze 提到幫我畫插畫的經驗。她說，也許有一天看九把刀的小說的熱情會緩下來，但她覺得隨著時間與相處，她發覺真正更吸引她的是──作家的人格。

我精神一振。

這個精神一振，讓我從心情的谷底坐火箭衝了上去。

每次想到就覺得很有力量。

大概 Blaze 會覺得我幫她寫序是一個很開心的事。

但，其實我非常高興，有這樣的機會可以表達我對 Blaze 的感謝。

不是可能。

Blaze 的插畫絕對會站上國際舞台。

多年後我會猛然驚覺，原來幫 Blaze 寫序，是我這輩子做過最猛的事之一！

知名作家

, o The Girl is Good

From a small time arrogant writer to a big time best selling author, many people have helped me along the way, and those people are very good at what they do. With their help, I learned to be humble.

This article is about how I met with one of them.

The year is 2005, 5 years after I started writing.

Just when my books' sales volume started to improve, my mother was sick.

During the chemotherapy, I stayed in the hospital with her, writing day and night, hoping to see the hope. One day, the result of the first Fantasy Art Illustration Award (White Tiger Award) came out. Although it had nothing to do with me, I surf the internet to check on it, just to pass time.

Of course there are a lot of great works, but I couldn't take my eyes off the blue one with two young fishmen girls sitting on the shore watching the ocean. The image was surrounded by a layer of aura. It showed great promising.

I checked the rank. Not the champion, but the fourth place?

Oh my god, this is not about undiscovered potential...

This is about someone who's being seriously underestimated; someone who was already a master.

Afraid of someone might beat me to it, I made two phone calls right away, asking two publishers to contact with the artist, to see if he's willing to do covers and illustrations for my books.

Then I realized that this "he" was a "she", who went by a name full of power, "Blaze (Furious flame)", which sounded right with Giddens. Afterward, I learned that Blaze was my fan, and it appeared that she's very happy to work with me. I felt so good.

Blaze is not only good with drawing, but also good at her layout skill. Her works were very detailed. She likes my stories. She connects with them. The covers and illustrations she does are not just to "meet the publisher's demands", but to respond with my stories and my emotions.

Blaze is good.

And she is becoming even better.

Because Blaze never cease to improve herself.
She never limits her styles. she is willing to try out all kind of drawing. She learns something from every case she takes, building her own Blaze Style. This kind of "no limitation" self challenge is surely harder than "repeating yourself again and again". Still, I have to say, we all got something different to bet with, and we all got something different in return.

There is one thing Blaze doesn't know.

Sometimes, you just inspire someone else without even knowing it.

Last year, a student imitated one of my stories, won a contest, denied what he did, called me a liar, and attack me. The whole event made me pissed, and there were some people took the chance to dishonor my credit. I had to stop writing Ha Bang, my Boss II for awhile. Fuck. It's like several nuclear bombs going off in my little nerdy world for several days on a roll, made me wanted to pick up the earth and throw it away.

I was pissed for a long time, much longer than you think.

One day, I saw a video clip of some student interviewing Blaze on the internet. Blaze mentioned the experience of doing the illustrations for my books. She said, maybe one day the enthusiasm of reading Giddens' books would cool down, but with the time spending with me, she realized what really attracted her was... the personality of the author.

I was shocked.

I was shocked like a rocket launched from the bottom of the spiritual valley to infinity and beyond.

Every time when I think about it, I can feel the strength rolling inside me.

Maybe Blaze is happy that I wrote the recommendation for her.

But the truth is, I was very happy to have the chance to express my gratitude to Blaze.

It's not just possible,

I am sure that Blaze's illustrations will go international.

And years later, I will suddenly realize that writing this article for Blaze is the most valuable thing I ever done in my whole life.

Top author

目 錄 Catalog

獻給四耳狐狸的祭典
The festival for the Four-eared Fox
2009

因伐木廠、工廠與鐵路的侵入，森林被嚴重破壞，
森林裡的精靈與動物們不得不遷離。

牠們在離開前作了最後一次的祈禱與祭典。
當作獻給無法離開的森林守護神──四耳狐狸的道別。

作品所參與的計劃
2009 夜貓館咖啡屋《消失的祭典》主題聯展
公益畫集《For You, For Me.》。

Because the log factory, industrial factory and railways stationed into the forest,
forests has been deforested, all the fairies and animals forced to move out.

They had one last prey and sacrifice before leaving, as for the farewell to the
Four-eared Fox, the guardian spirit of the forest who cannot leave.

Participated projects
"The Vanished Sacrifice" : YaMyouKan 2009 Art show in Taiwan,
and the charity art album For You, For Me.

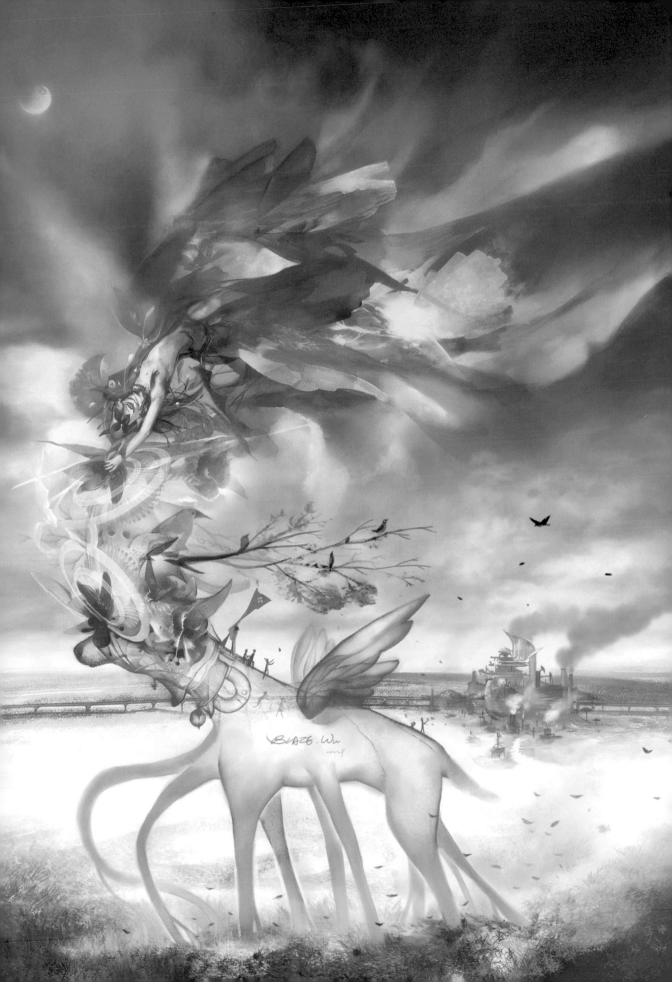

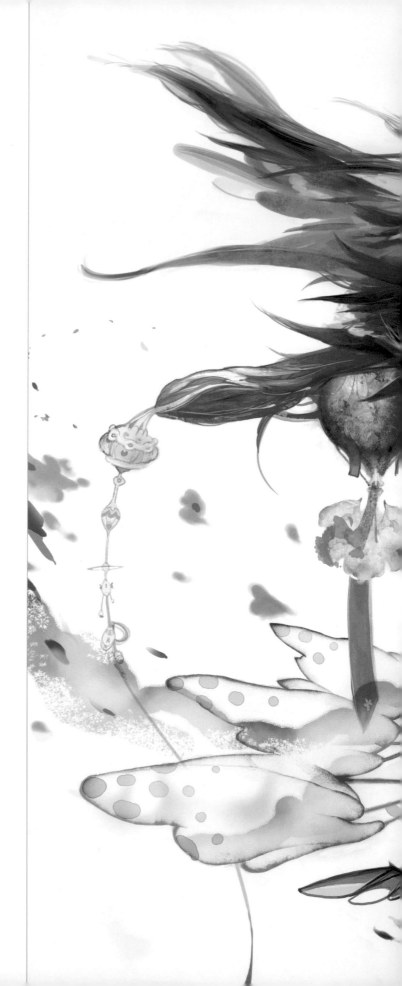

, °

狐狸小姐
Lady Fox
2007-2009

四耳狐狸的使者，
使用笛子召喚並安撫
森林中的動物靈。

「德律風少女」的姊妹作。

Envoy of Four-eared fox,

Using flute to summon and soothe animals'
soul in the forest.

The sequel illustration for "Telephone girl".

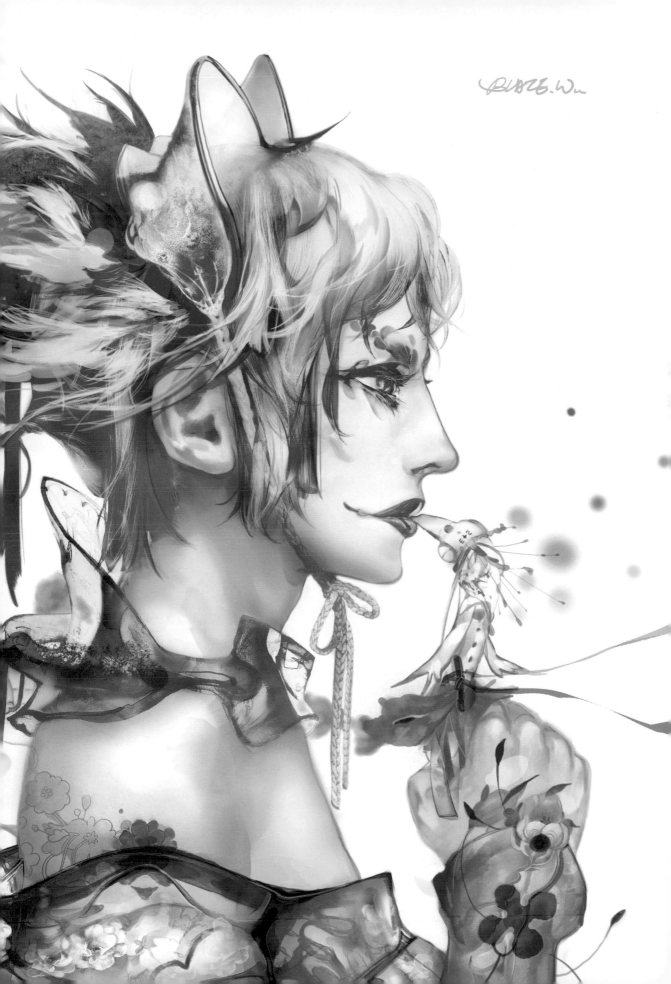

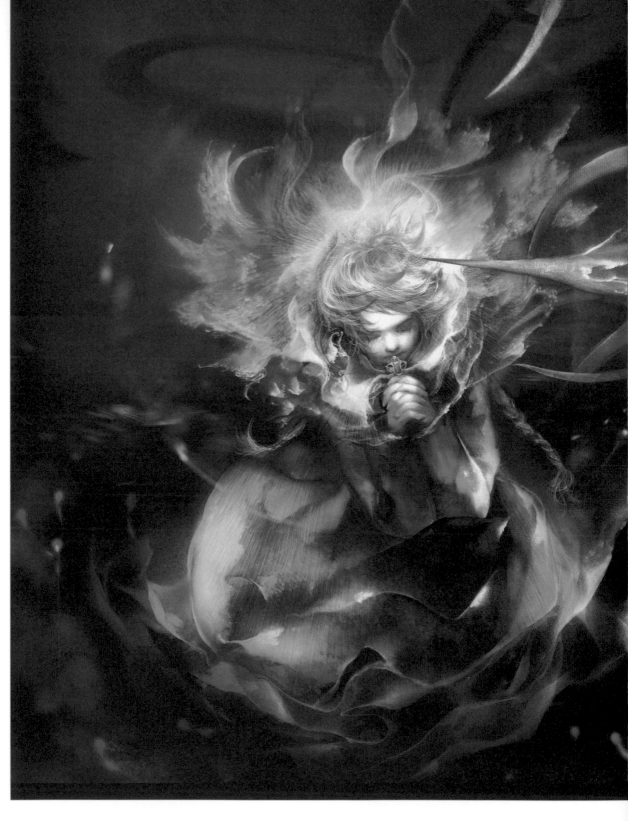

，°　惡魔的庭園
Devil's garden
2009

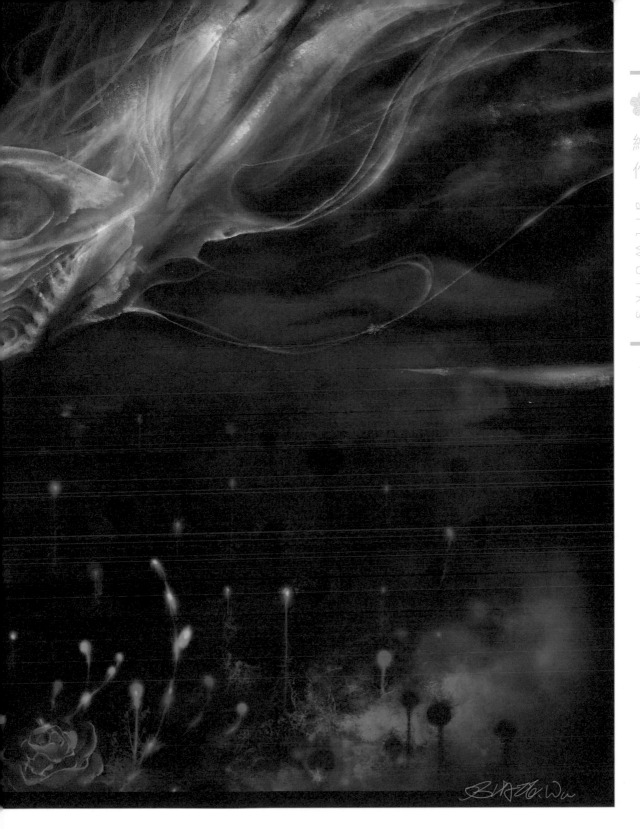

小說插畫《地獄債》⁺ 賽門 · 葛林著，蓋亞文化出版。
一隻惡魔在牠的庭園裡嗅聞擄獲的靈魂成熟了沒。

Illustrated for *Nightside #7*⁺. A novel by Simon R. Green.
Complex Chinese edition, published by Gaeabooks.
A devil is sniffing to see the Captures soul has been matured or not in his garden.

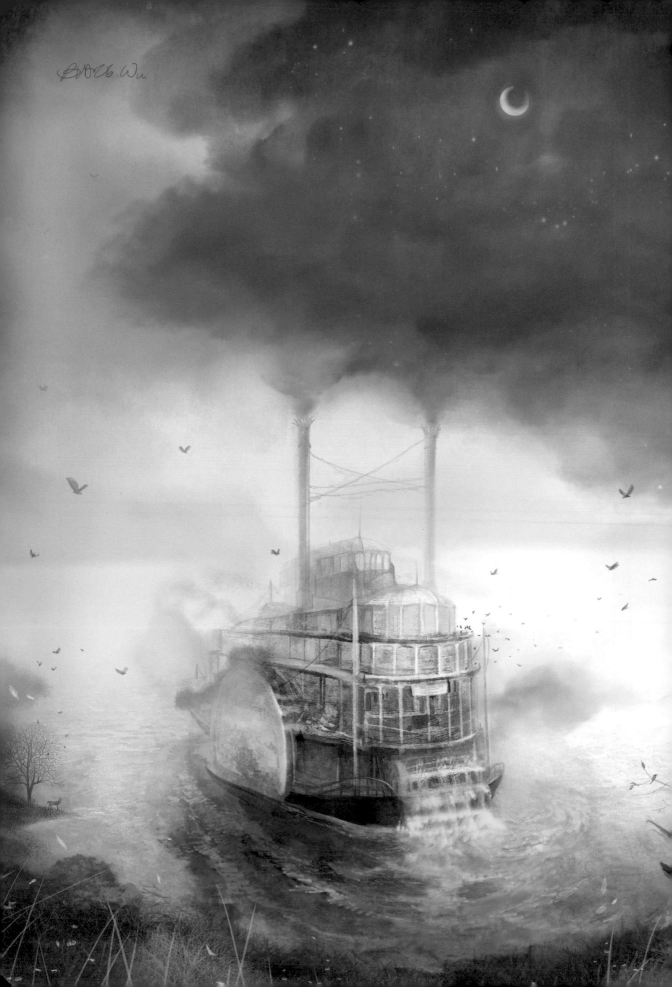

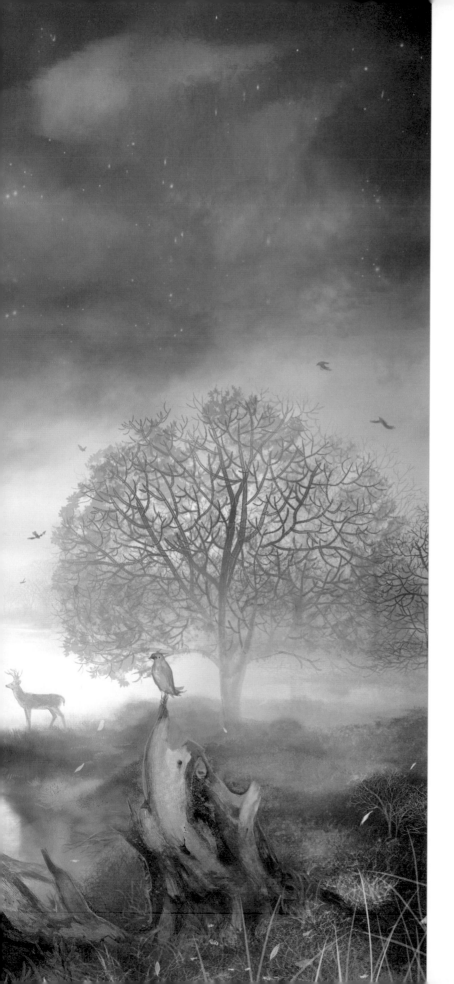

﹐°

熾熱之夢
Fevre Dream
2009

《熾熱之夢》台灣版封面插畫，蓋亞文化出版。

用煙霧蔓延形成夜空，來暗喻故事中的輪船和吸血鬼之間的關係。

This work is for the complex chinese edition of *Fevre dream*, published by Gaeabooks.

Using the smoke extended into sky, implied the relationship between the steamship and vampire.

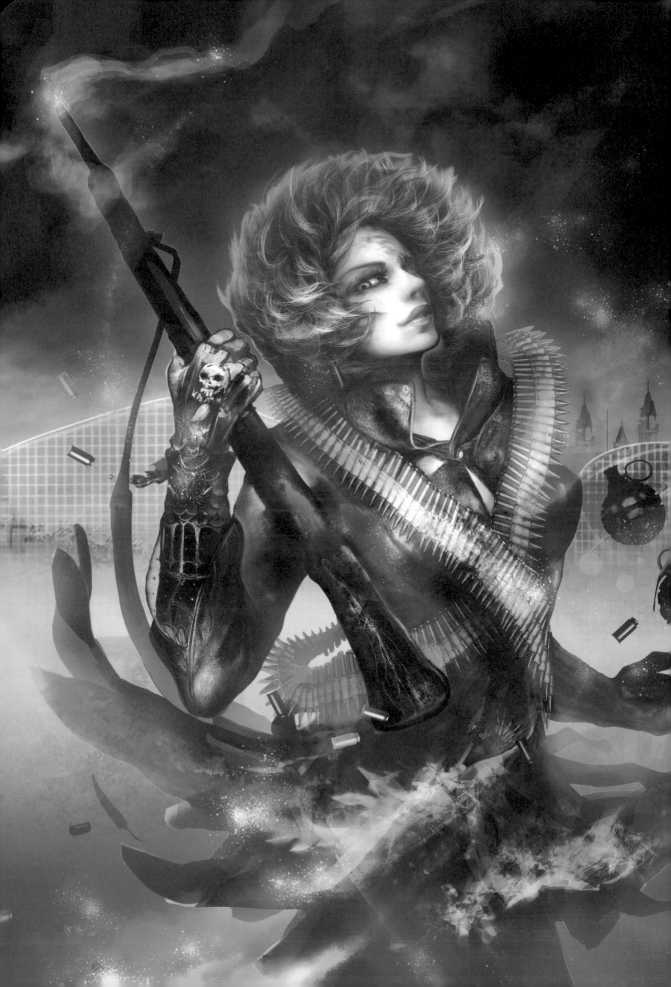

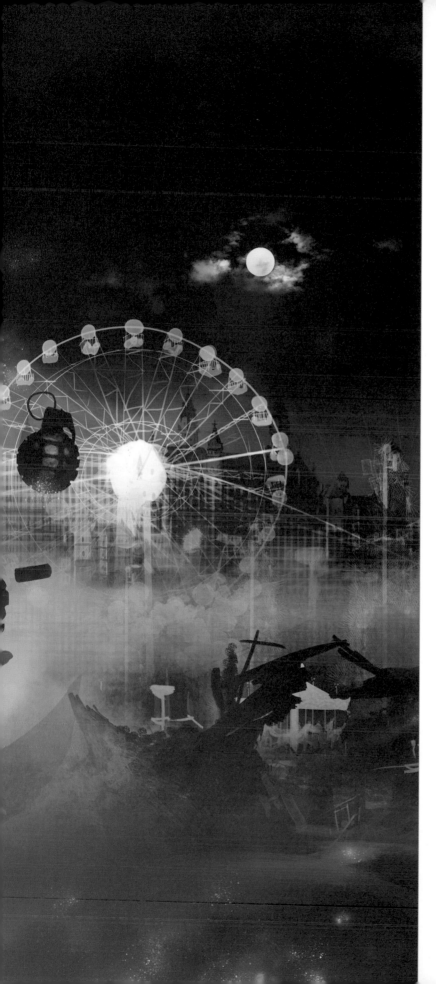

,°

蘇西・休特
Susie Shooter
2009

小說插畫《非自然詢問報》
賽門・葛林著，
蓋亞文化出版。

霰彈蘇西，又名
「喔，天阿，快跑，是她！」

Illustrated for *Nightside #8*. A novel
by Simon R. Green. Complex Chinese
edition, published by Gaeabooks.

Susie Shooter, aka Shotgun Susie or
"Oh Chris It's Her Run!".

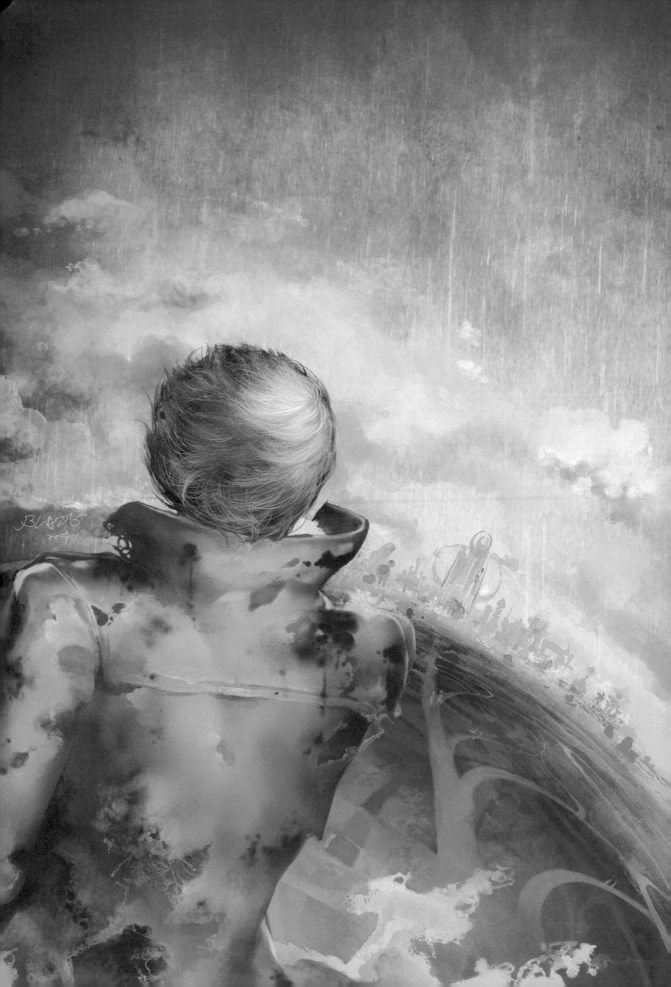

未來
Futurity
2007

小說插畫《錯過的旅途》
賽門・葛林著，
蓋亞文化出版。

眼前的未來是數不盡的路途。

Illustrated for *Nightside #5*. A novel
by Simon R. Green. Complex Chinese
edition, published by Gaeabooks.

The future lies ahead has countless
path for us.

』°

莉莉絲
Lilith
2007

小説插畫《毒蛇的利齒》賽門‧葛林著，
蓋亞文化出版。

頭髮與火的流動暗示故事的流向與莉莉絲所造成的
破壞與強橫。十字架則代表著死亡與創世。

Illustrated for *Nightside #6*. A novel by Simon R. Green. Complex Chinese
edition, published by Gaeabooks.

The flow of hair and fire suggest where the story goes and brutal damages
caused by Lilith. The cross is the symbol of death and creation.

L

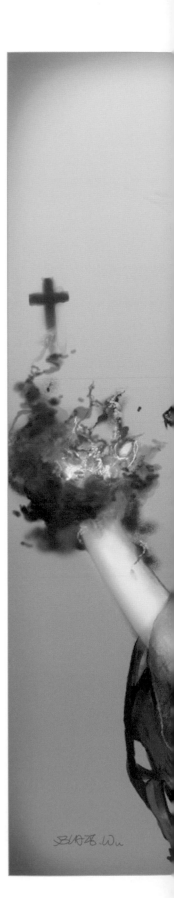

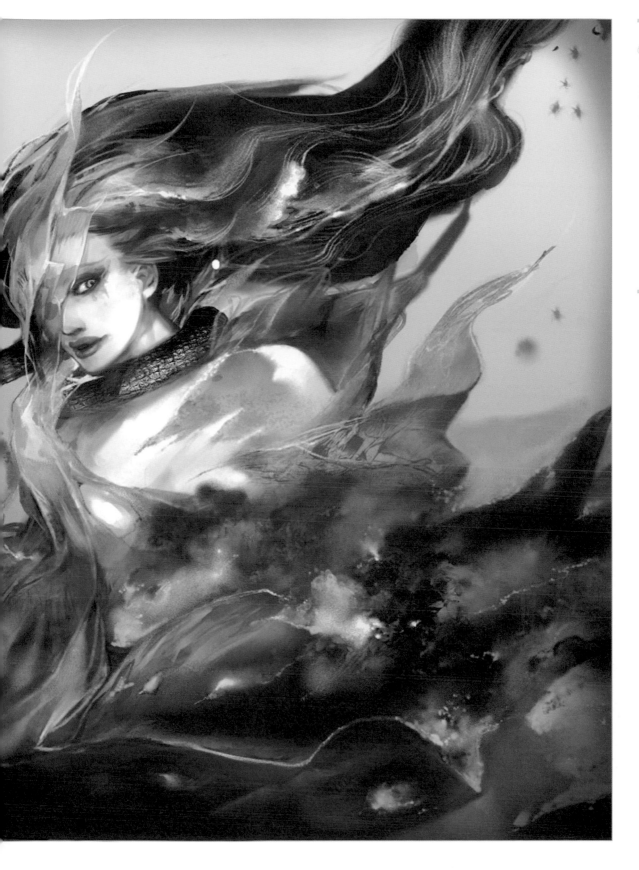

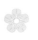

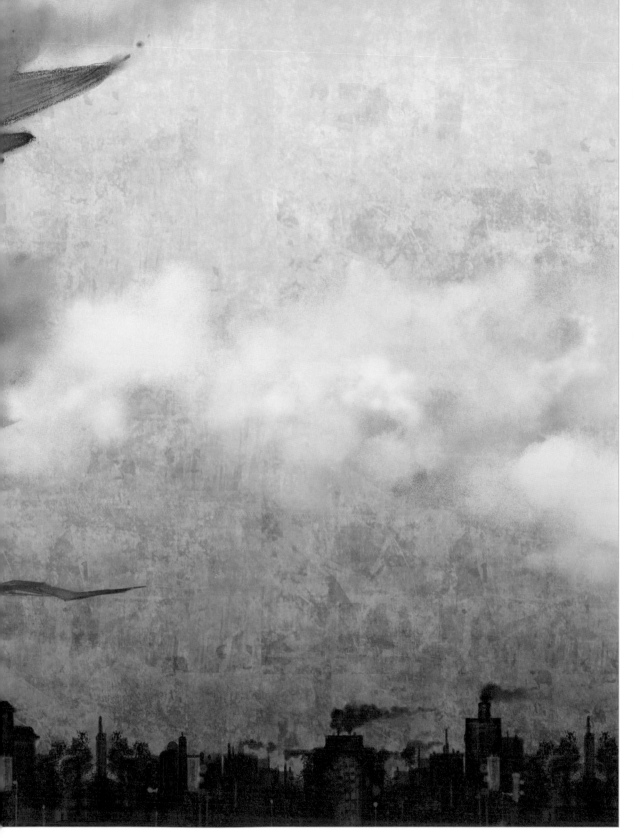

燃燒的天使
Burning Angel
2006

小說插畫《天使戰爭》賽門 · 葛林著，
蓋亞文化出版。

Illustrated for *Nightside #2*. A novel by Simon R. Green. Complex Chinese
edition, published by Gaeabooks.

,°

時間老父
Old Father Time
2008

小説插畫《影子瀑布》賽門 · 葛林著，
蓋亞文化出版。

頭上是時鐘扭曲所形成的冠冕，代表時間老父的權
威地位，背後是機械所堆疊而成的房間。

Illustrated for *Shadows Fall*. A novel by Simon R. Green. Complex Chinese
edition, published by Gaeabooks.

Above the head is a crown made of twisted clock, it represents the authority
of Time, in its back is a room stacked with machines.

L

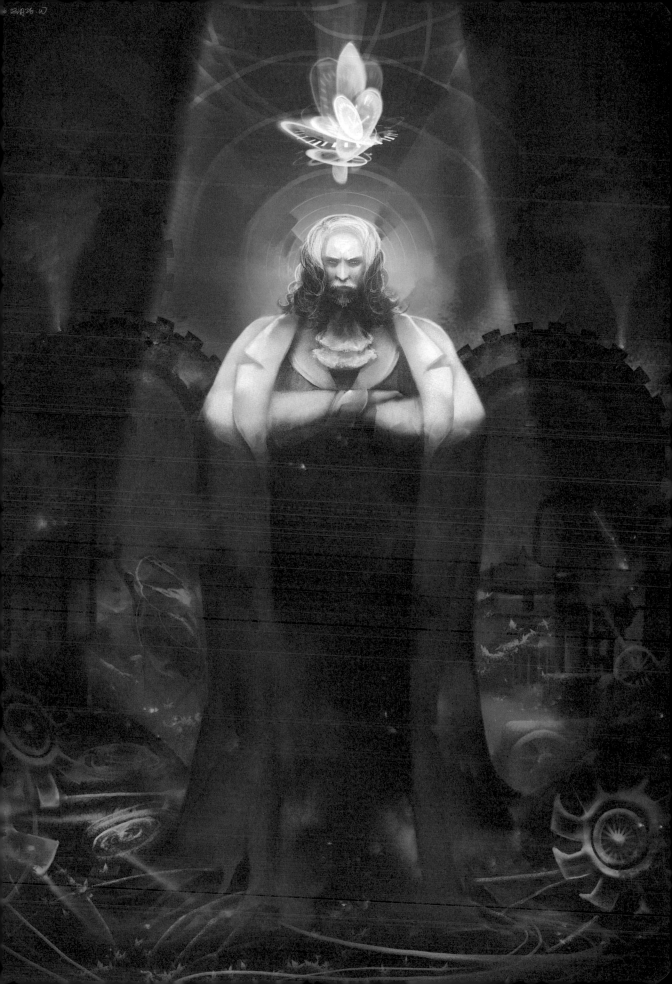

，。

魔女
The witch
2007

小說插畫《魔女回歸》賽門・葛林著，
蓋亞文化出版。

從壁畫中浮現出來的魔女。

Illustrated for *Nightside #4*. A novel by Simon R. Green. Complex Chinese
edition, published by Gaeabooks.

The witch emerged from the wall.

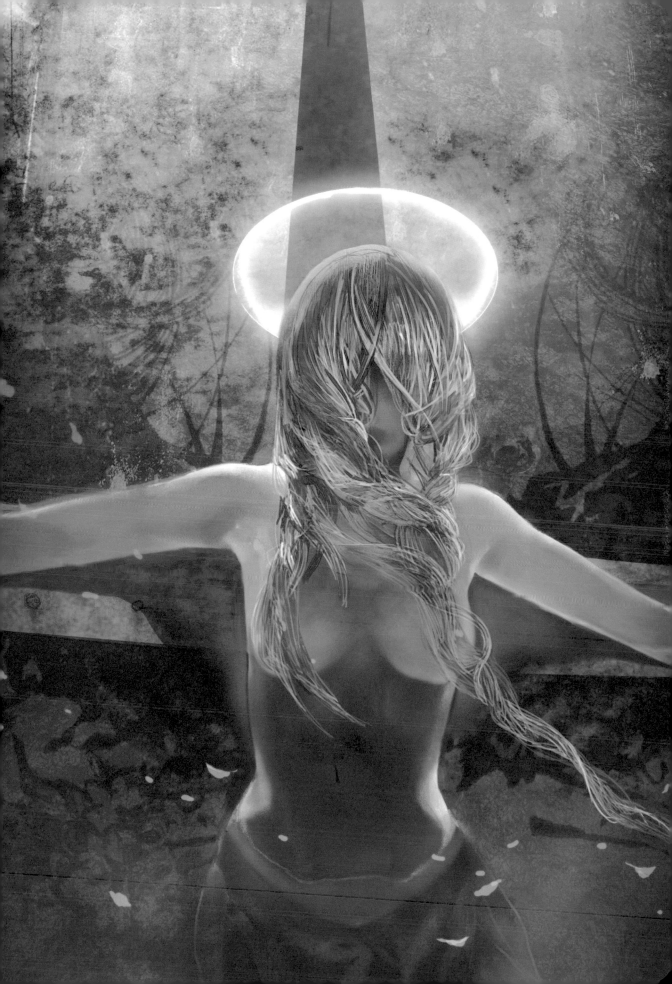

，° 受詛咒的燭台

Cursed Candlestick

2008

少女的靈魂受到詛咒，禁錮於長有翅膀的燭台，
不停燃燒著。燃燒的煙是她的臉龐與髮絲，痛苦
地流著淚，等待能解放她的人。

The soul of a young girl has been bewitched, and placed on the
candlestick which has wings, burning and burning. The flaming smoke
formed into her face and hair, tears dropped with pain, looking for
someone who could set her free.

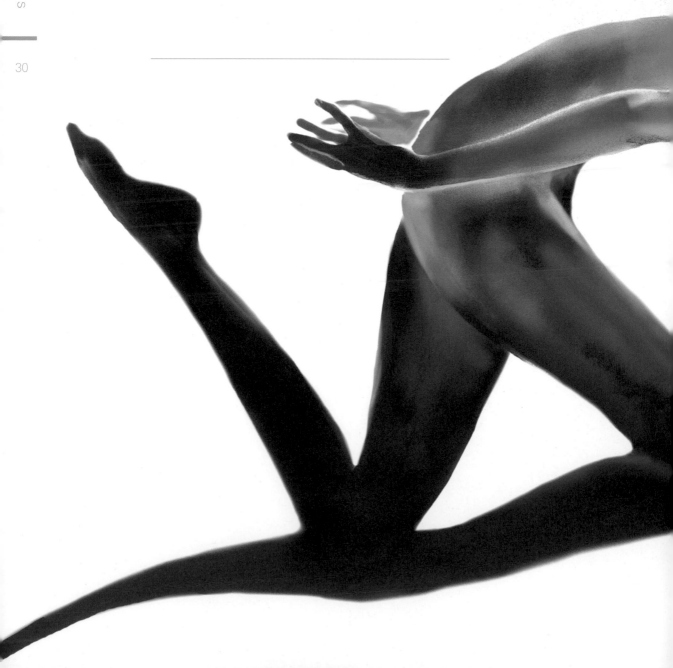

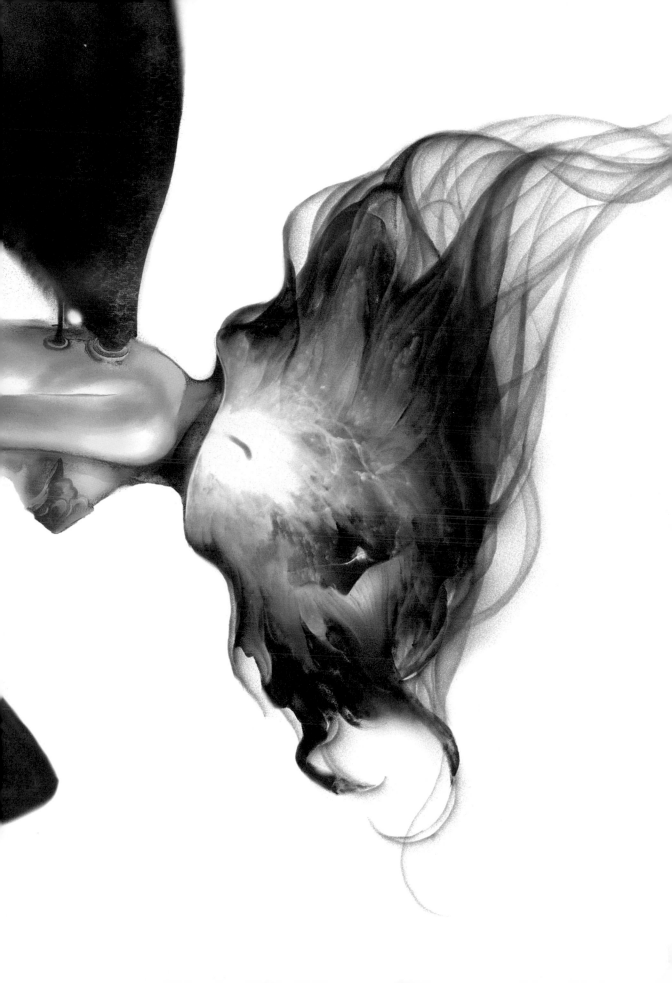

，° 默
Slience
2009

親民技術學院繪圖示範作品 +

Painting for Chin-min Institute of technology
Department of Digital Media Desifn.

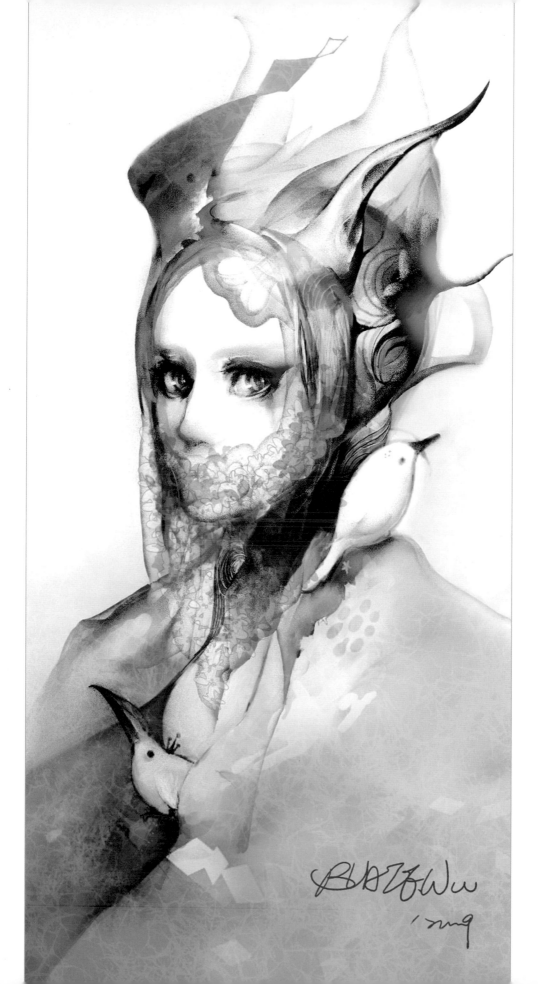

德律風少女
Telephone girl
2005

2005 年《德律風少女進化論》的畫作之一。

與作家夕月和插畫家 VOFAN 的三人合作畫刊。
夜貓館咖啡屋出版。

In 2005 *telephone girls evolutionism*
one of the illustrations.

the writer Xi-Yue and the illustrator VOFAN on three cooperation pictorial.
Published by yamyoukan.

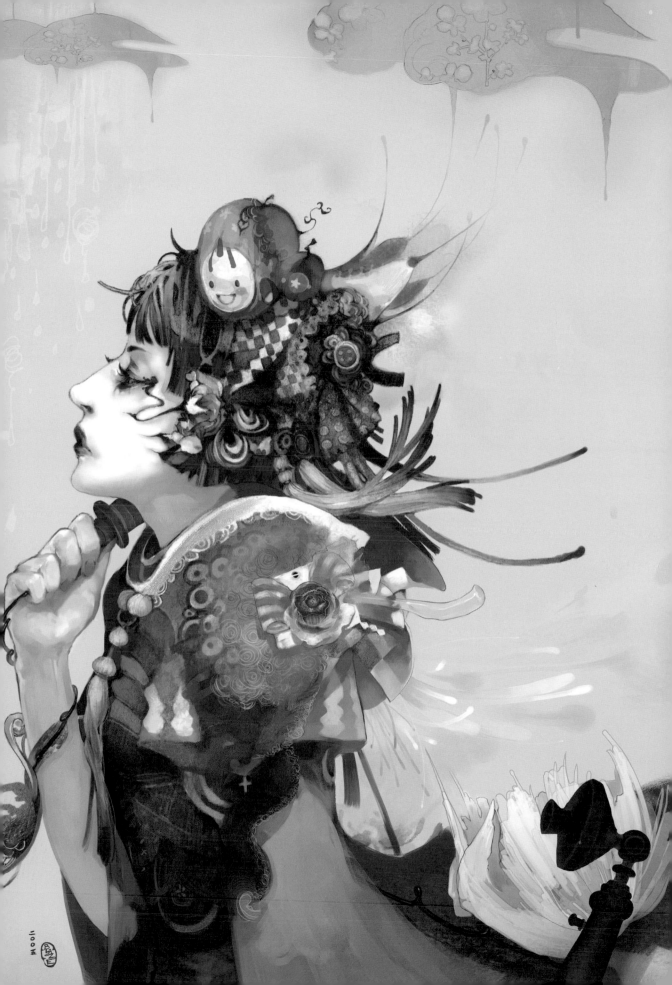

 葡萄園

Vineyard

2008

韓國小説《德莫尼克》卷八封面插圖。
蓋亞文化出版。

以彩虹與樹屋帶出魔法奇幻感。

Illustrated for Korean novel: *Demonic #8* Complex Chinese edition,
published by Gaeabooks.

To use the rainbow in the sky and a tree house produce a feeling of magic and fantasy.

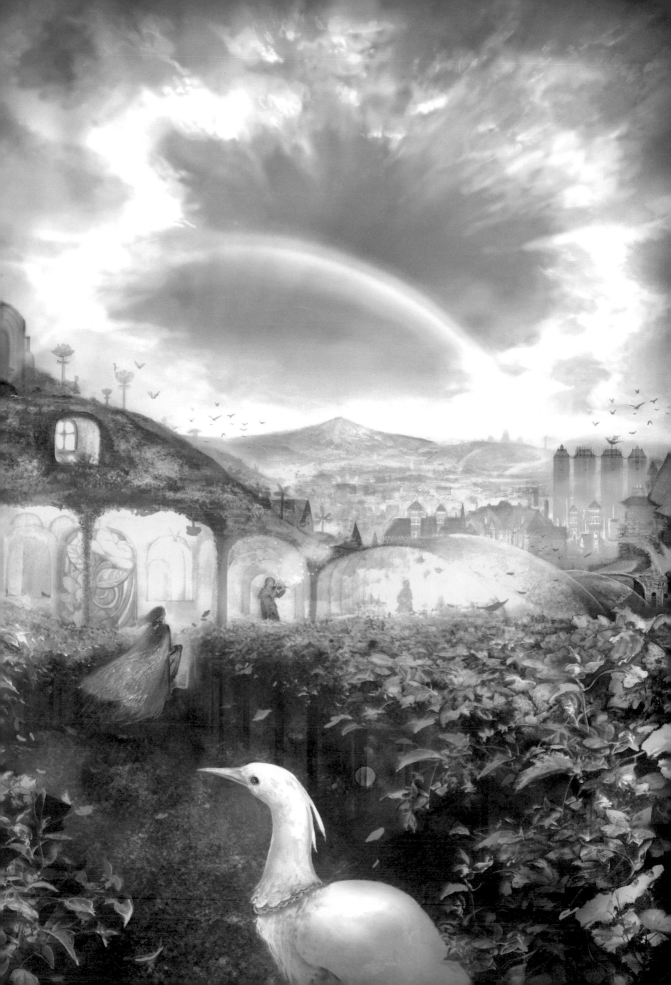

⁊° 幽靈少女
Phantom girl
2008

韓國小説《德莫尼克》卷七封面插圖 +
蓋亞文化出版。

幽靈少女與食夢貘相偕前往魚之國度，
但入境時發現魚已被鳥吃掉大半了。
以帶點童話氣氛的超現實風格，傳達作品的氣氛。

Illustrated for Korean novel: *Demonic #7* Complex Chinese edition,
published by Gaeabooks.

Phantom girl went to Fishland with the dream eater,
but when they enter the land, most fishes has been eaten by birds.
Perform the feeling with surrealism and fairy tale.

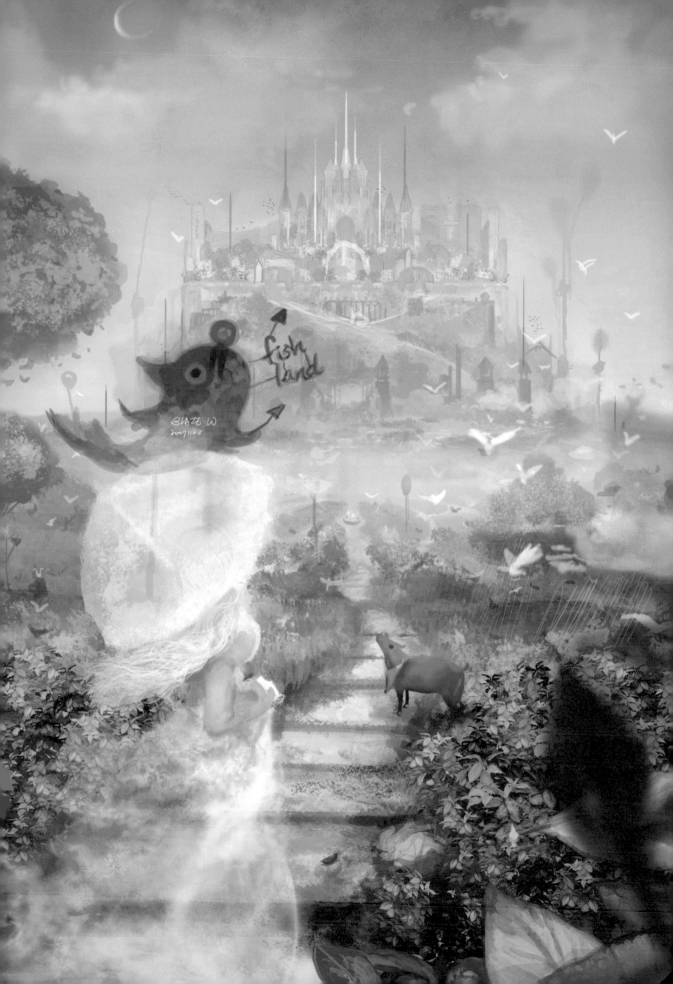

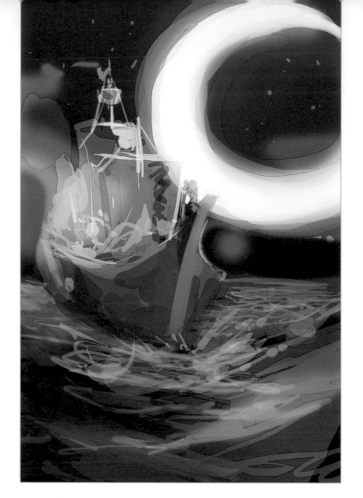

，。

月夜之下的海盜船
A corsair in the moon night
2007

韓國小說《德莫尼克》卷六封面插圖。
蓋亞文化出版。

Illustrated for Korean novel: *Demonic #6*.
Complex Chinese edition, published by Gaeabooks.

L

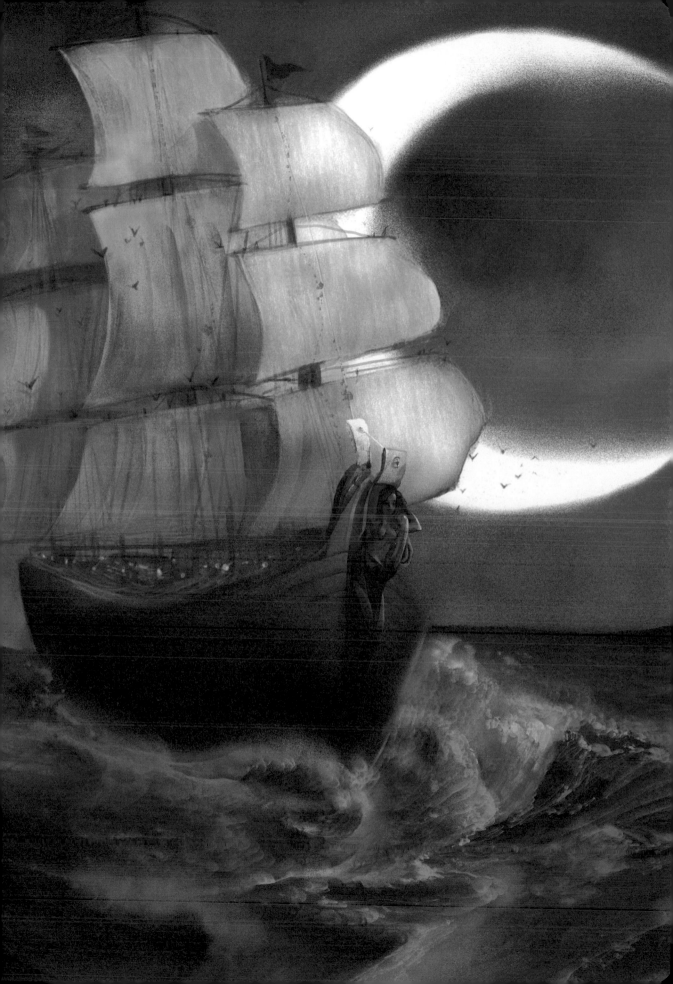

，° 墓園
Cemetery
2006

韓國小説《德莫尼克》卷五封面插圖。
蓋亞文化出版。

喜歡雲還有風吹的感覺。

Illustrated for Korean novel: *Demonic #5*.
Complex Chinese edition, published by Gaeabooks.

I like the cloud and feeling of the wind.

ㄴ

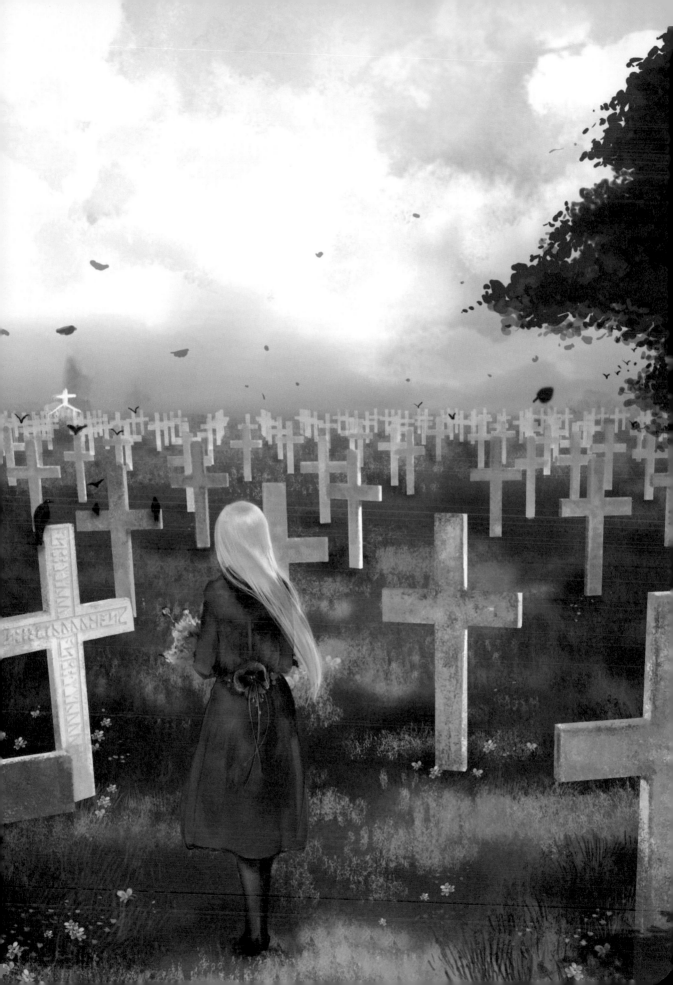

ˎ ° 黃昏碼頭
Boat Dock Sunset
2006

韓國小說《德莫尼克》卷四封面插圖。
蓋亞文化出版。

想咬一口飄帶的鳥。

Illustrated for Korean novel: *Demonic #4*.
Complex Chinese edition, published by Gaeabooks.

A bird wants to bite the scarves.

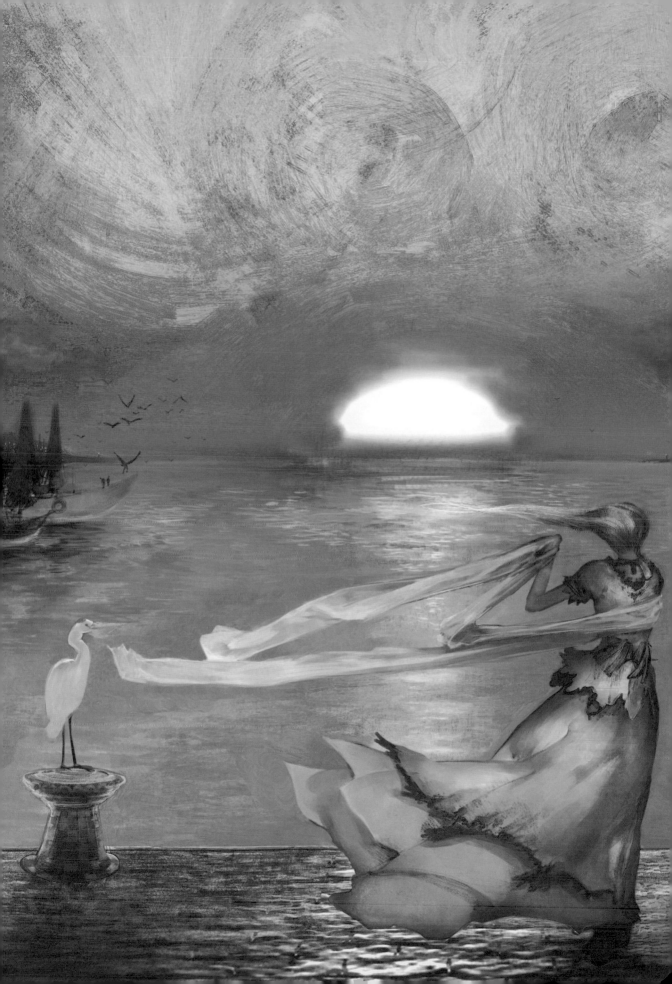

⌐° 飛船
Airship
2005

韓國小說《德莫尼克》卷三封面插圖。
蓋亞文化出版。

燃料是昂貴的黃金。

Illustrated for Korean novel: *Demonic #3*.
Complex Chinese edition, published by Gaeabooks.

The fuel is the expensive gold.

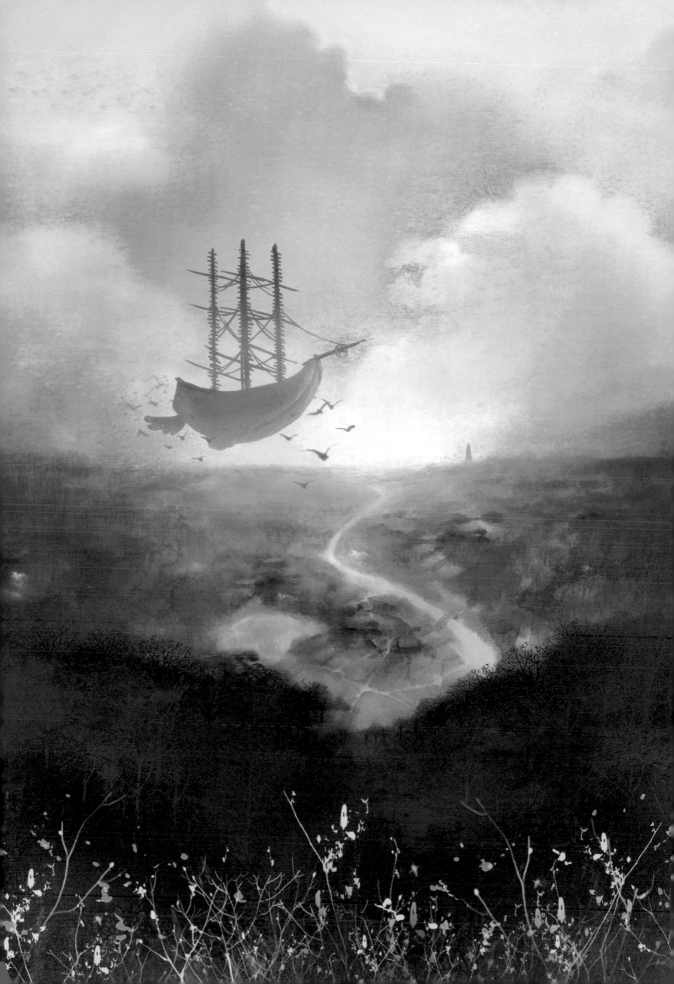

，°
擁抱喬伊
Embrace joy

2008

一位女性好友失戀而陷入傷心欲絕，朋友們都很想幫助她走出來。我發現當不知道要怎麼安慰她時，只要給她一個擁抱，什麼都不必説就能撫平心裡的創傷，讓心靈一片安寧。她也會回給我有力的擁抱，不可思議地也讓我溫暖。

出於這樣的心情，我創造了一個角色，叫作 Joy，意思是喜樂，種族是鳥人。她是個飛行家，最喜歡在乾燥寒冷的天氣旅行，若是看見傷心的旅人，便會給他一個放著點點光芒、溫暖的擁抱。

我想在作品中表達擁抱那一刻所感受到的，是一種白白亮亮、小小的、閃著光的感受，因此想用旋轉舞台燈在畫布後面所閃耀的光芒，隱密的暗示著。

希望這個作品能予人快樂與安詳的祝福。

One of my girl friend broke up with her boyfriend, fell into sadness and grief. All of her friends tried to help her to get out, and that was when I found, it only need one hug to soothe the pain inside.

So I created JOY, which means delight, she is a bird person, a pilot, loves to fly in dry, cold weather. If she saw someone sad on the trip, she'll give them a warm embrace.

I want to express the feeling at the moment of embracing, it is white and glowing, so I used rotating stage lights to imply secretly behind the canvas.

I Hope this work will bring happy and serene blessing to people.

L

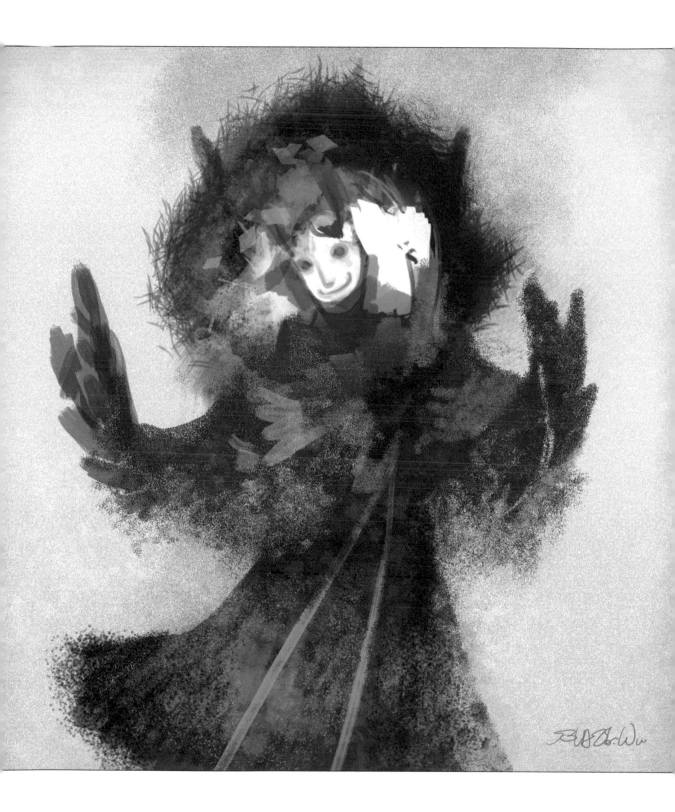

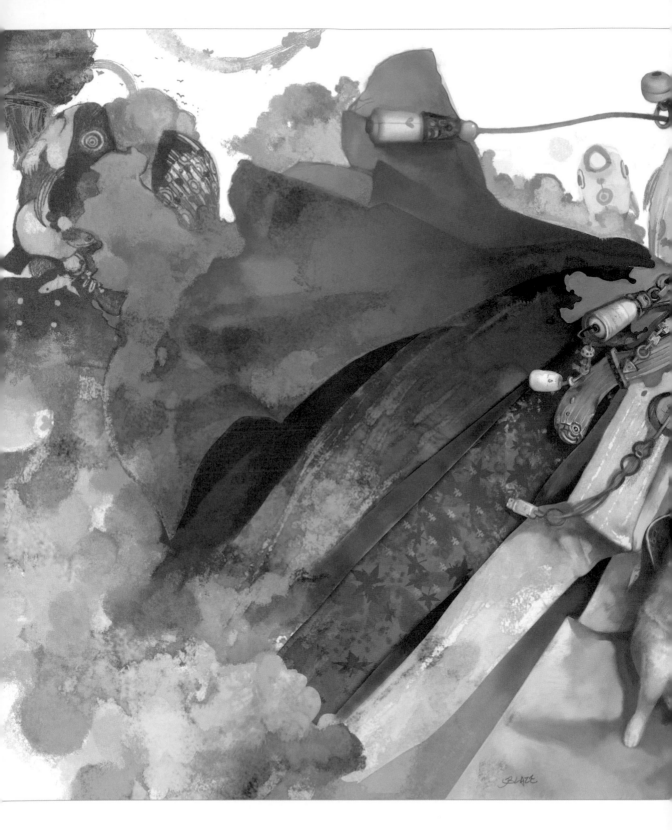

,° CG 娘與貓王子的冒險
The adventure of CG girl and cat prince
2006

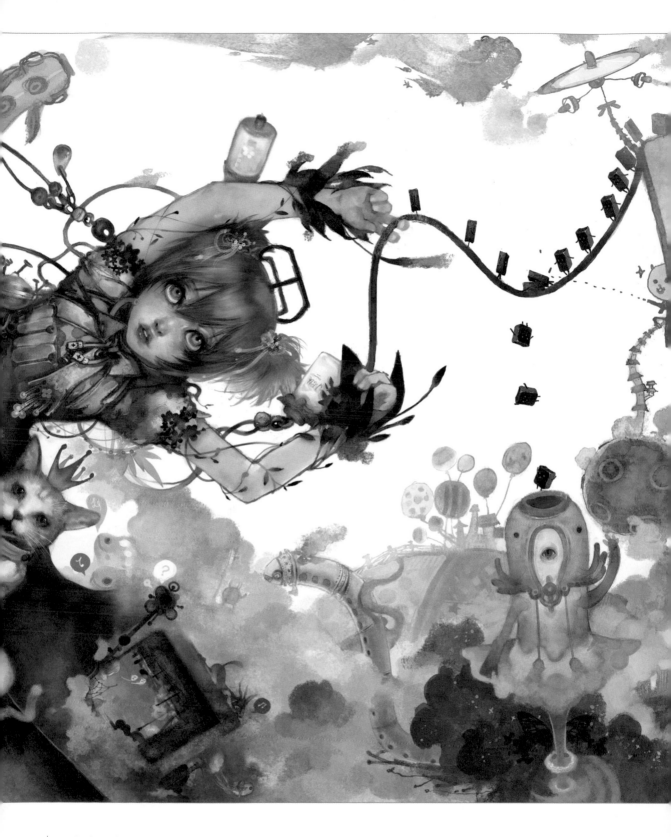

多人編製電繪教學書《CG Smart II》的封面插畫,角色原案:Pump。
碁峰資訊出版。

The multi-people establish the CG teaching book *CG Smart II* cover illustration, the role original case: Pump.
Published by GOTOP INFORMATION INC..

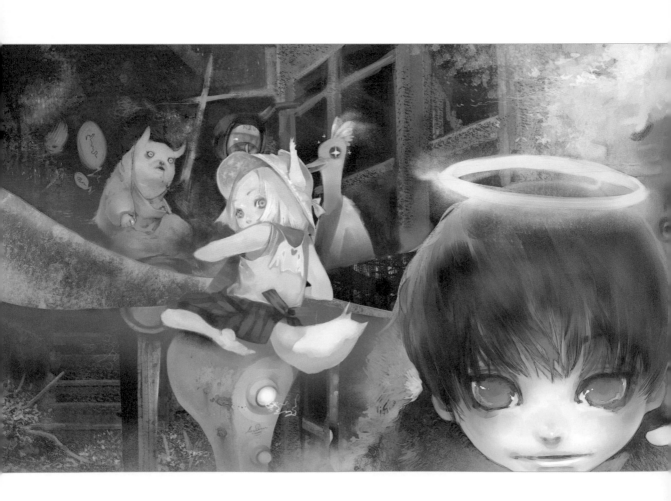

孒° 孩子們的秘密基地
The secret base of children
2005

夜貓館咖啡屋出版。參與主題原創插畫誌
《BOPEEP01 孩子們的秘密基地》。

右後面的滑壘小孩，是繪本《萬花》的角色萬花小時候。

Published by yamyoukan.
To participate in the theme of original illustrations.

BOPEEP01 children's secret base.

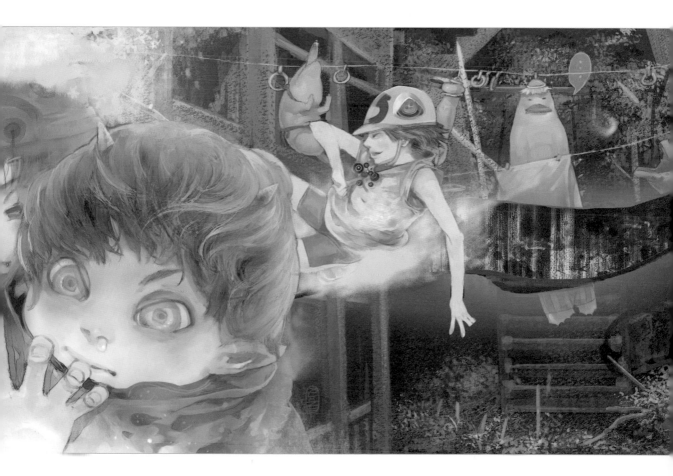

，° 德律風人妖
Telephone shemale

2005

2005 年《德律風少女進化論》的畫作之一。

與作家夕月和插畫家 VOFAN 的三人合作畫刊。
夜貓館咖啡屋出版。

In 2005 *telephone girls evolutionism*
one of the illustrations.

the writer Xi-Yue and the illustrator VOFAN on three cooperation pictorial.
Published by yamyoukan.

L

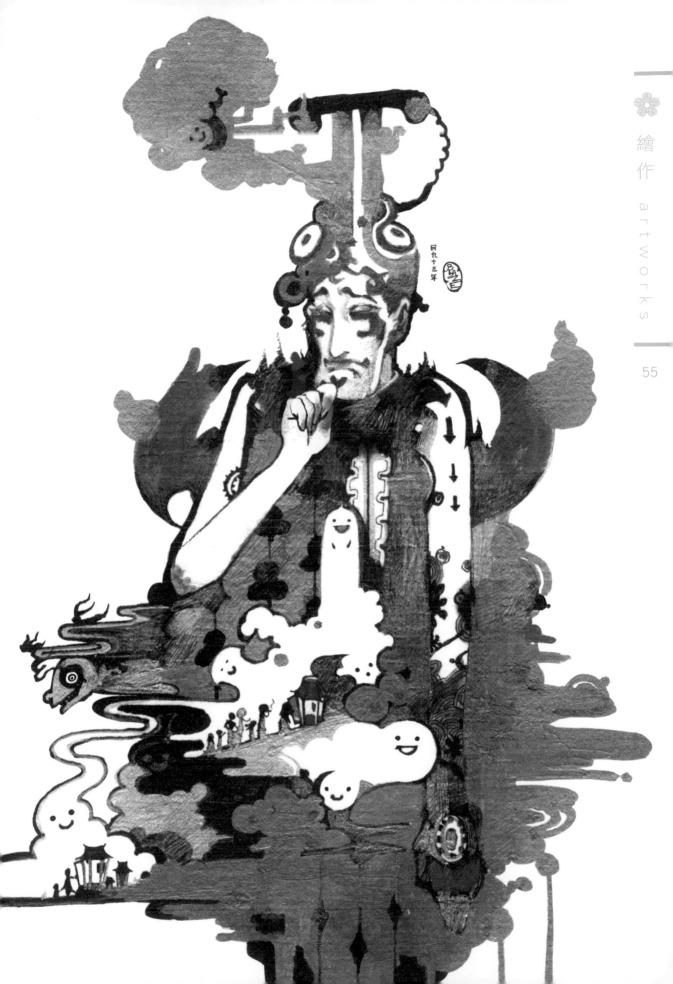

Valentine's Day
Illustration by Blaze

情人節快樂
Happy Valentine's Day
2004

為了情人節所畫的圖。

Painting for Valentine's Day.

﹐。

海水之女
Daughter of the seawater
2004

海水的女兒，喜歡鮮艷色彩，衣服和裝飾都是以海水幻化而成──往往不久後就會化去。

Daughter of seawater likes bright colors, her clothes and accessories are transformed from seawater, but soon will be melted.

∟

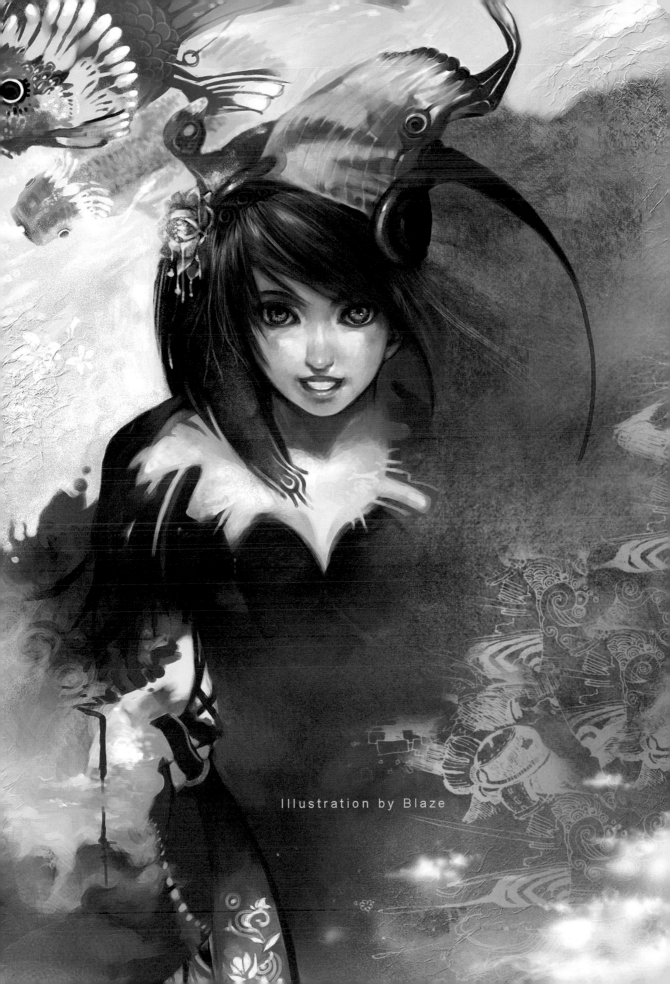

Illustration by Blaze

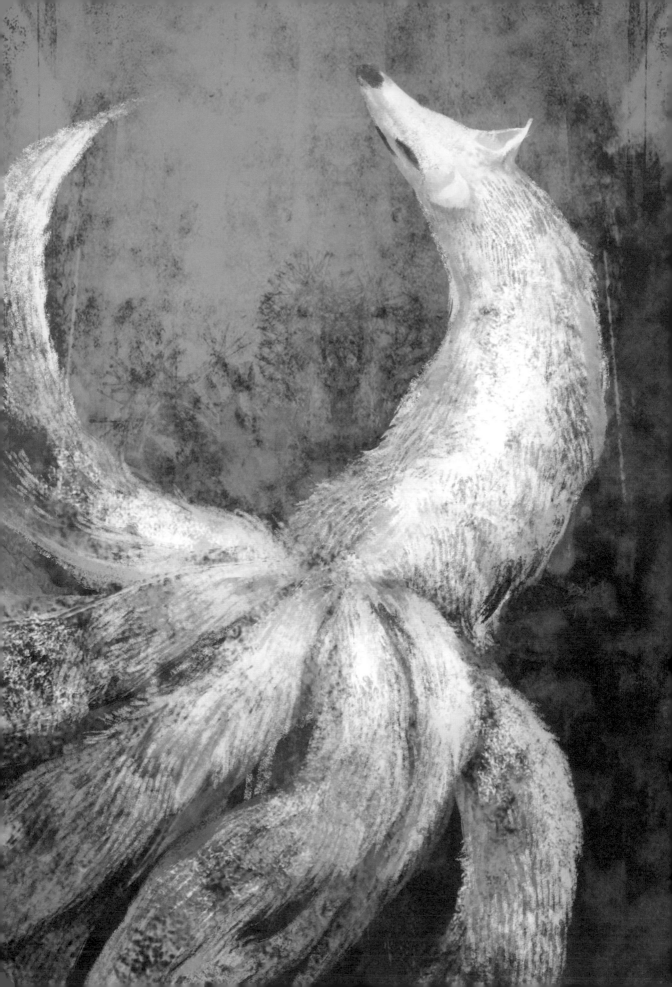

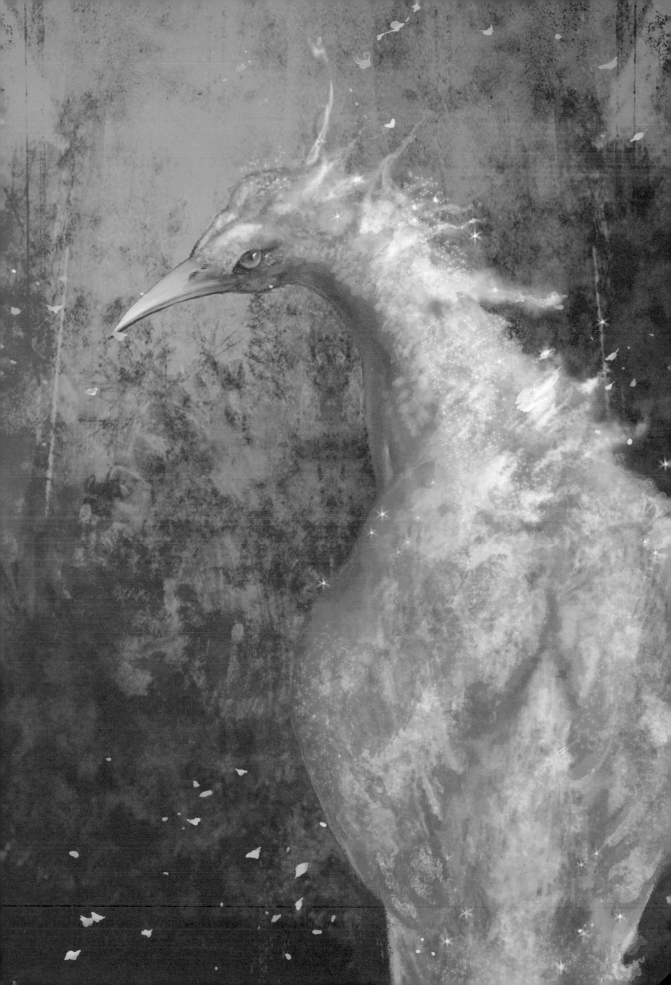

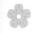

,°

都市妖奇談（新版）
City Legends of Monsters
2007

小説《都市妖奇談》新版插畫。蓋亞出版。

為初版四年後的新版而畫。

This work is for *City Legends of Monsters*.
Complex Chinese edition, published by Gaeabooks.

Renewed illustration after 4 years publication.

L

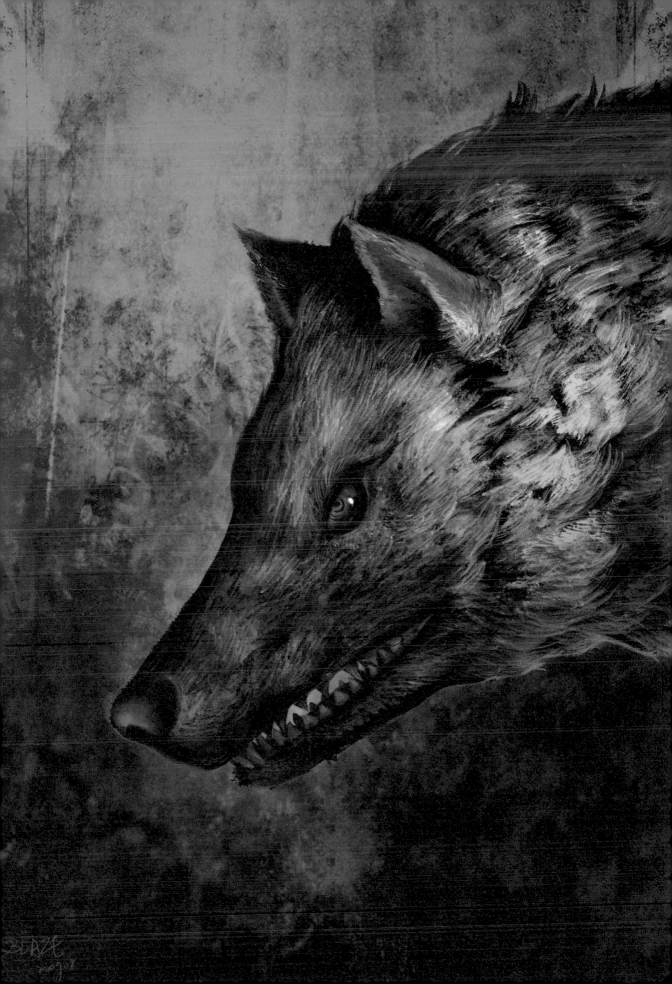

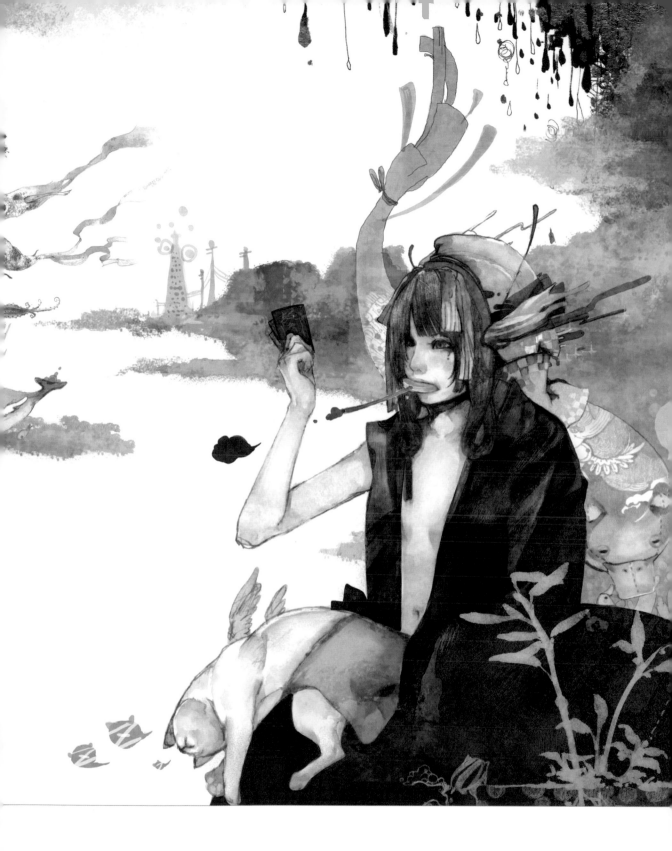

，°
玩牌
Playing Cards
2005

日本飛鳥新社《ss》雜誌內頁跨頁插畫繪製

The 2 pages-illustration for *SS magazine* from Asukashinsha publishing.

貓娘
cat girl
2003

金絲貓，2003 年獻給夜貓館咖啡屋的賀圖[+]。

Golden Cat, felicitations for Yamyoukan[+].

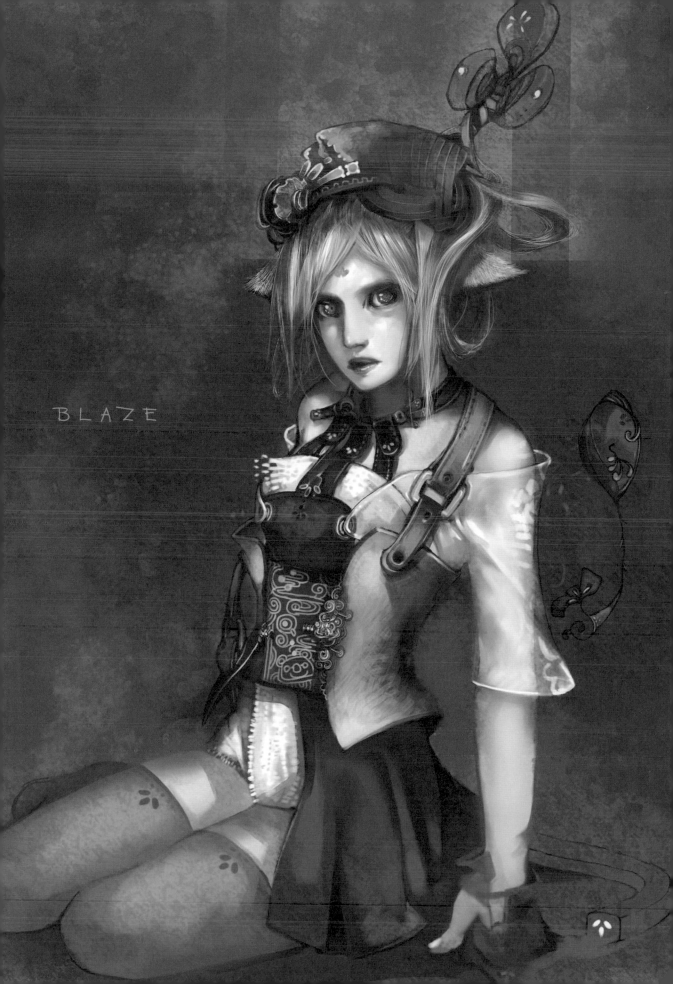

,°

仙人
Celestial being
2004

負責管理魂池的仙人 [+]。

The celestial being is in charge of the pool of soul[+].

L

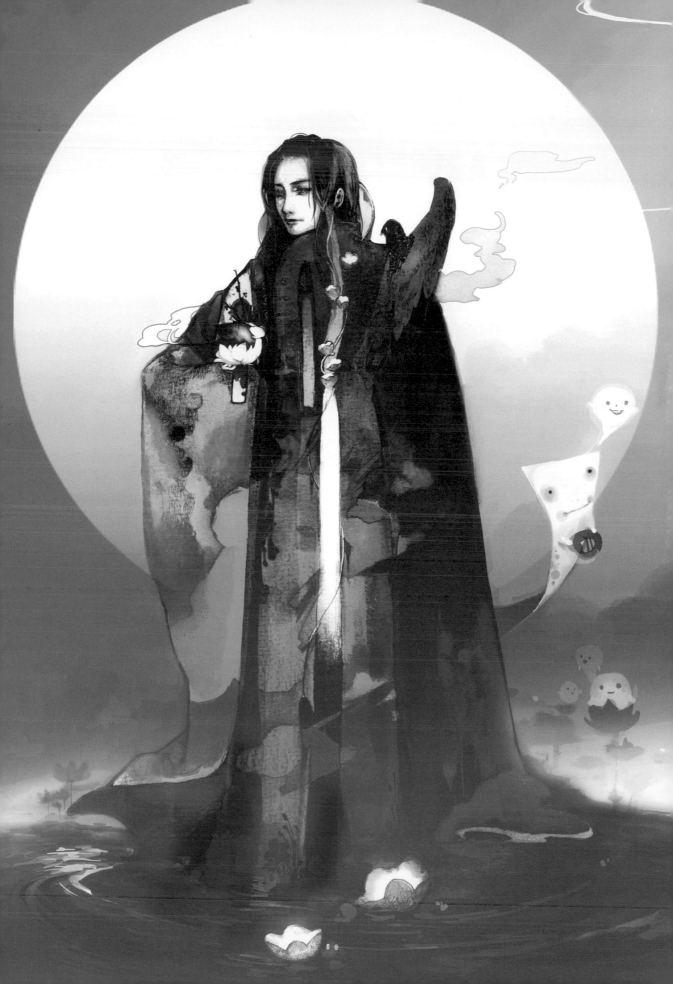

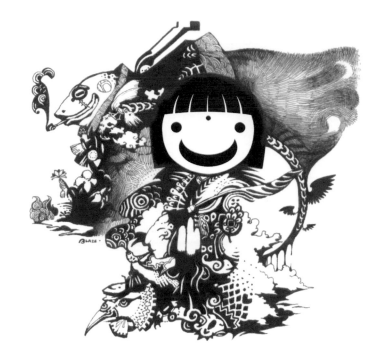

’。

惡魔
Devil
2004

小哈塔羅牌——惡魔牌繪製。

VOVO Tarot —— the devil card.

∟

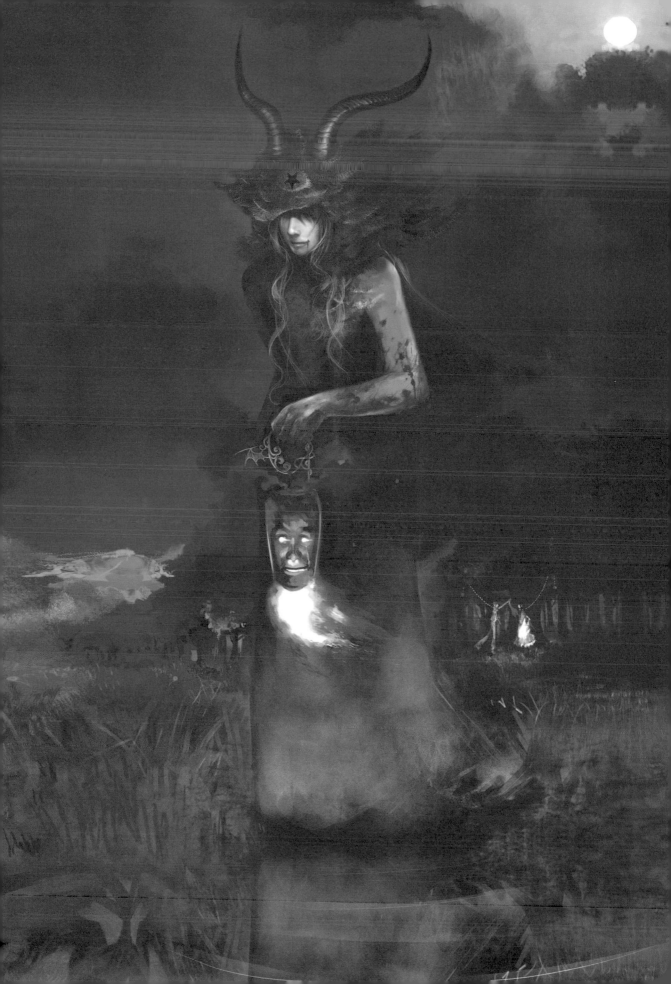

恭賀新禧
Happy New Year
2003

大街上充滿著外星人的新年。

The street is filled with aliens during the New Year.

∟

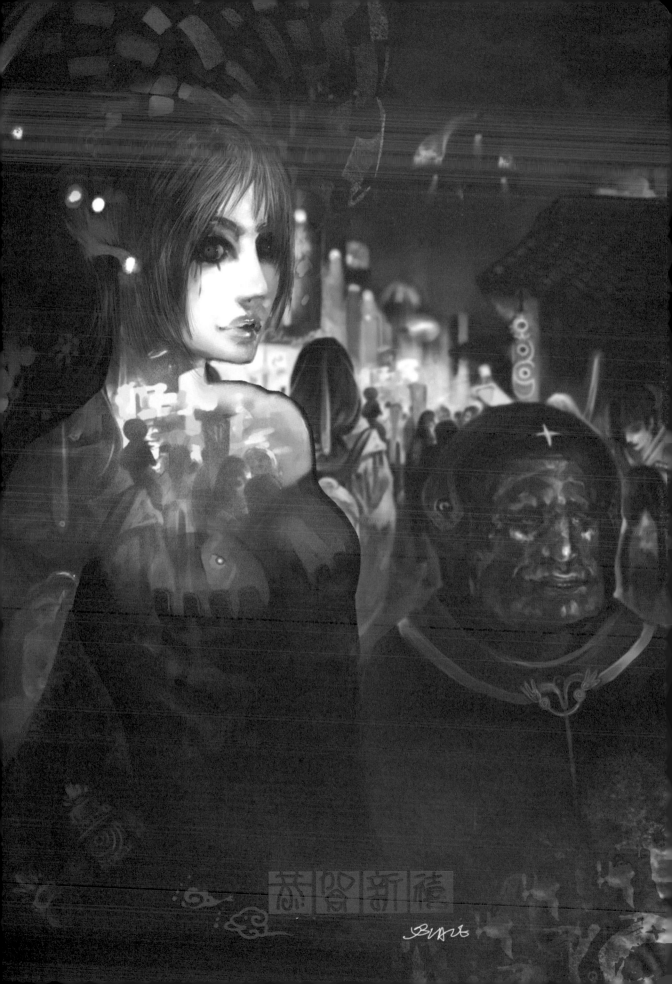

╹。

夜鶯
Nightingale
2006

小說插畫《夜鶯的嘆息》賽門・葛林著，
蓋亞文化出版。

如同安徒生童話中的夜鶯，她的歌聲有著蠱惑人心
的穿透力，以靈魂歌唱著。

Illustrated for *Nightside #3*. A novel by Simon R. Green.
Complex Chinese edition, published by Gaeabooks.

As the nightingale in Andersen's Fairy Tales, the sound of her singing was
bewitched with penetration, singing with the soul.

∟

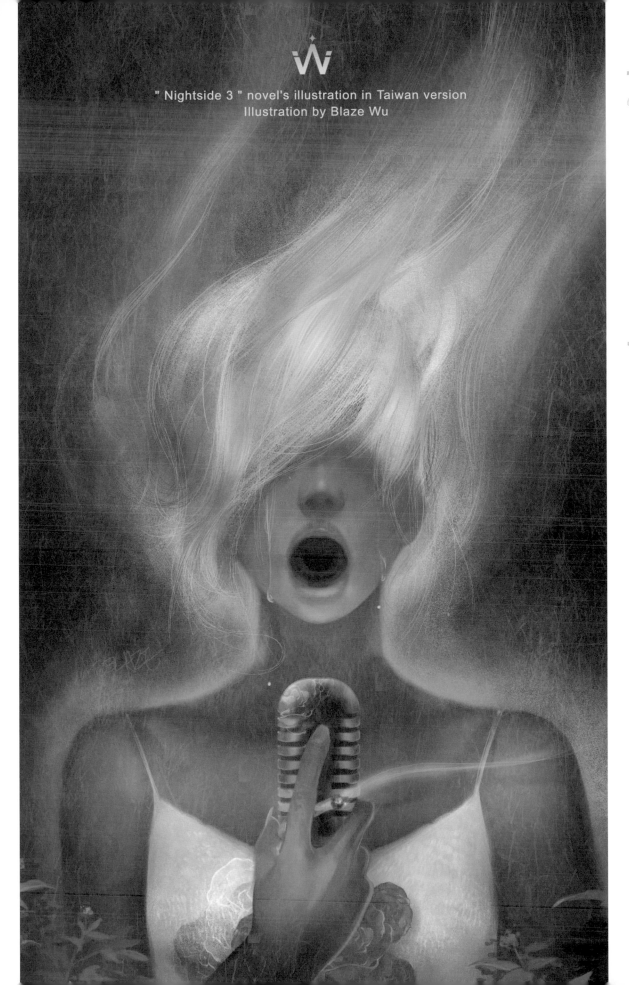

" Nightside 3 " novel's illustration in Taiwan version
Illustration by Blaze Wu

海邊的訊息接收站

The message receiving station by the seashore
2004

聽著音樂吹著風。
第一屆奇幻藝術獎白虎獎佳作。

Listening to music and blowing wind.
The First Fantasy Art Award honorable mention.

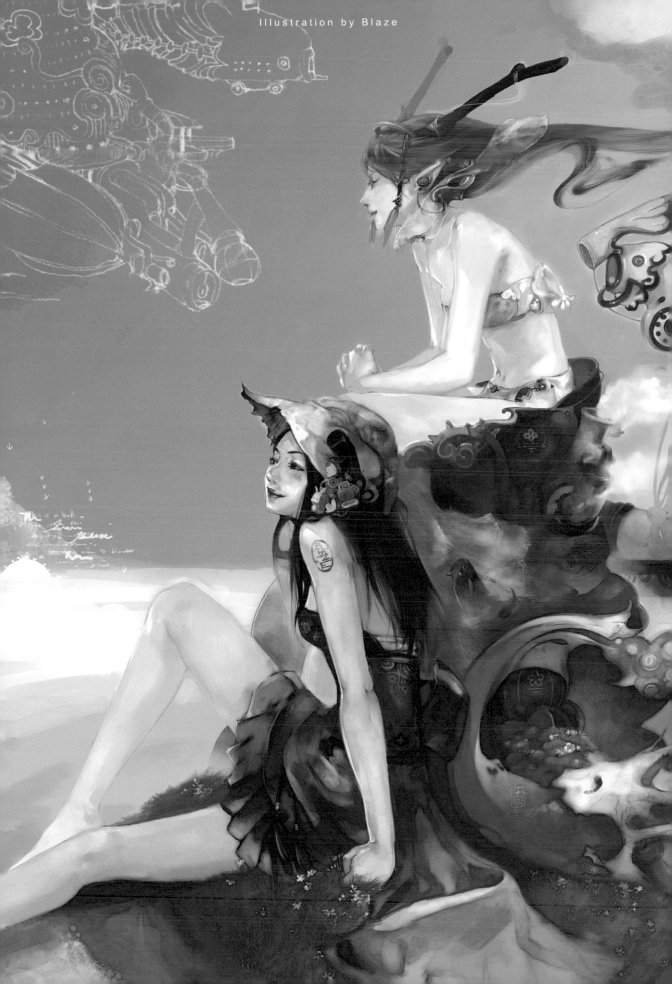

Illustration by Blaze

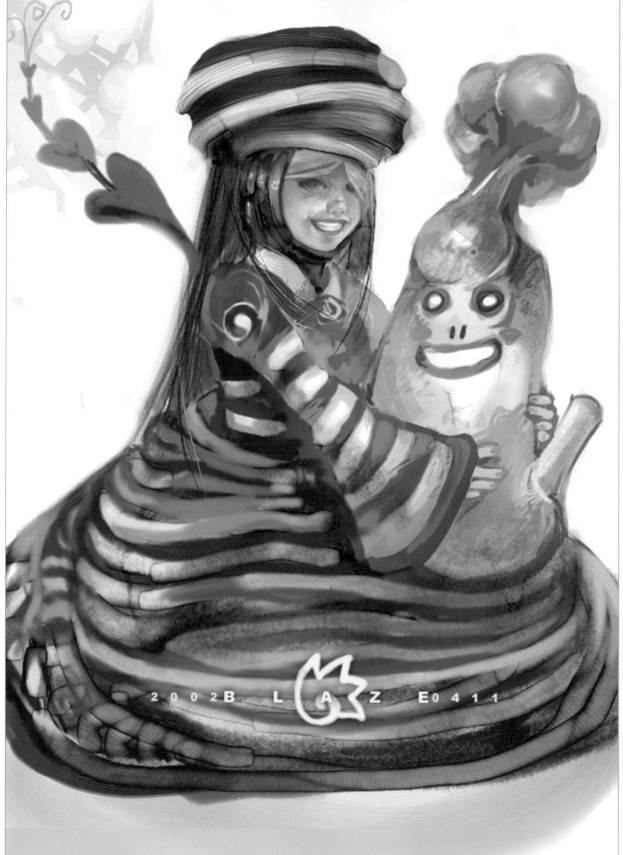

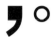

莎拉阿拉公主
Princess Sarah Allah
2002

IQ 很高的天才，個性開朗，偏愛蔬菜的造型。手
上拿的是她最近研發出來的武器，名為「愛笑的菜
子」。

She is a high IQ genius with cheerful personality, and vegetable style is
her favorite. The weapon on her hand is recently developed the "Laughing
Nanako".

破碎的娃娃
The Broken Doll
2002

橫臥在廢物堆上的機器人，

一點點的生命、
一點點的訊息、
一點點的回憶⋯⋯

The robot lying on the waste piles,

With a little bit of life,
a little bit of message,
a little bit of memory...

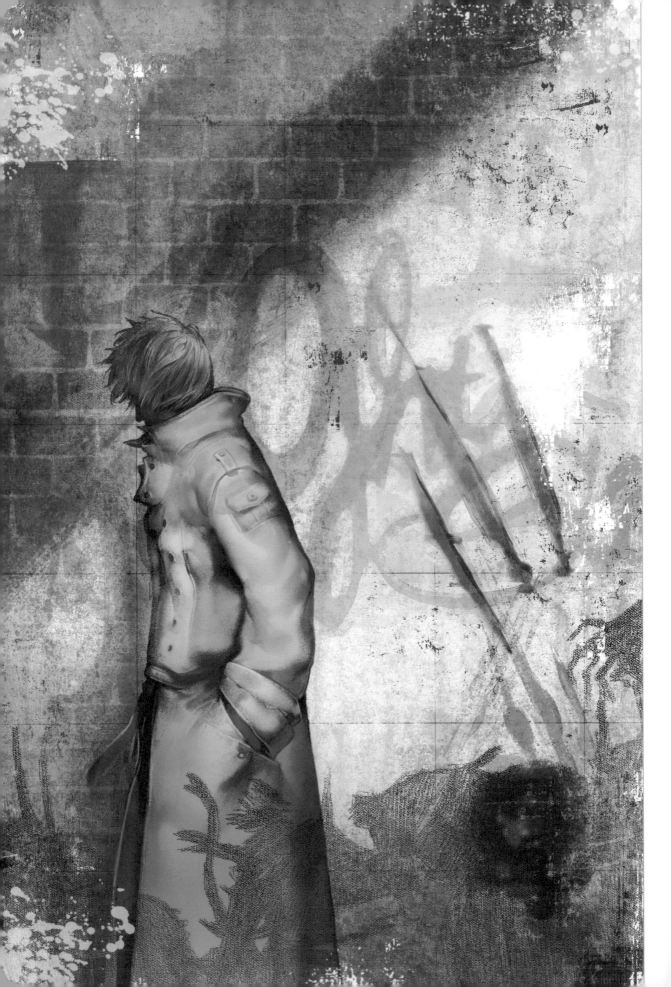

偵探
Detective
2006

小說插畫《永夜之城》賽門・葛林著，
蓋亞文化出版。

Illustrated for *Nightside*, a novel by Simon R. Green.
Complex Chinese edition, published by Gaeabooks.

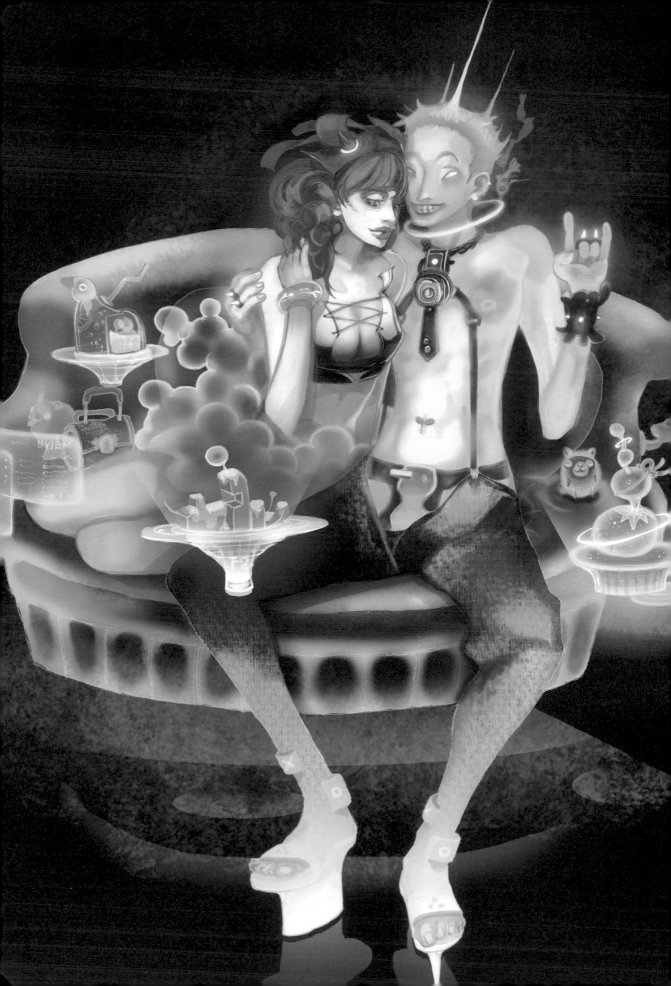

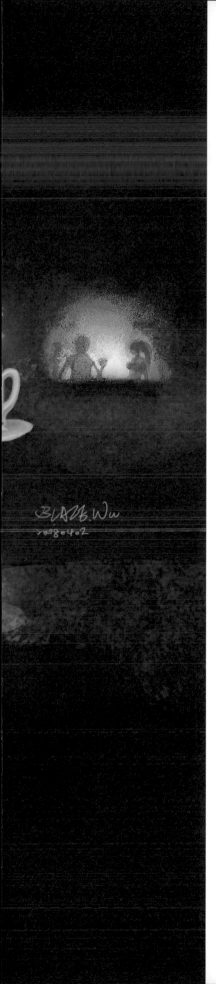

,。

點亮世界
Light up my life
2008

九把刀短篇小説〈點亮世界〉的插畫之一，
收錄於九把刀中短篇小説傑作選《綠色的
馬》，蓋亞出版。

Illustrated for "Light up my life", one of the short story in *The Green Horse* by Giddens, published by Gaeabooks.

綠色的馬
Green Horse
2008

九把刀中短篇小說〈綠色的馬〉的插畫之一，收錄於九把刀中短篇小說傑作選《綠色的馬》，蓋亞出版。

Illustrated for "Green Horse", one of the short story in *The Green Horse* by Giddens, published by Gaeabooks.

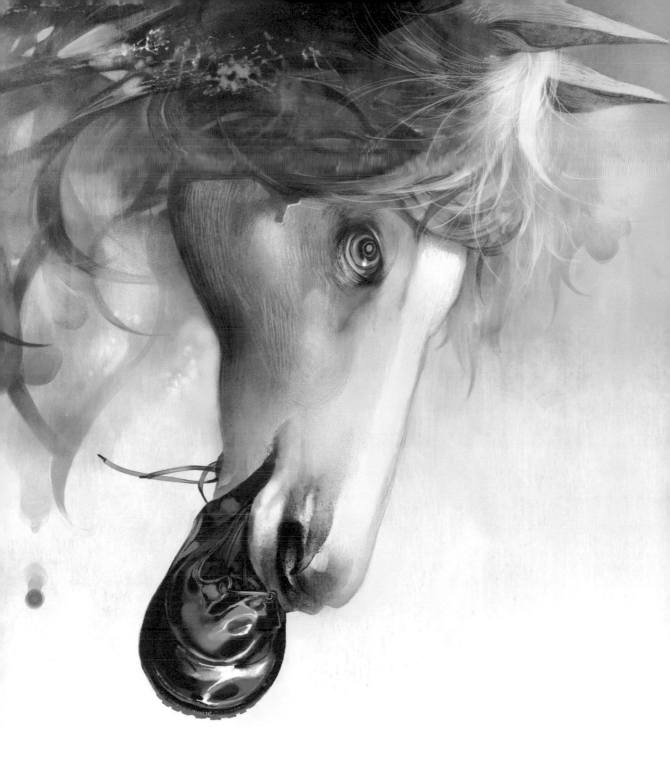

﹐°

屍體
A dead body
2008

九把刀短篇小説〈兇手〉的插畫之一，收錄於九把刀中短篇小説傑作選《綠色的馬》，蓋亞出版。

Illustrated for "Muder", one of the short story in *The Green Horse* by Giddens, published by Gaeabooks.

L

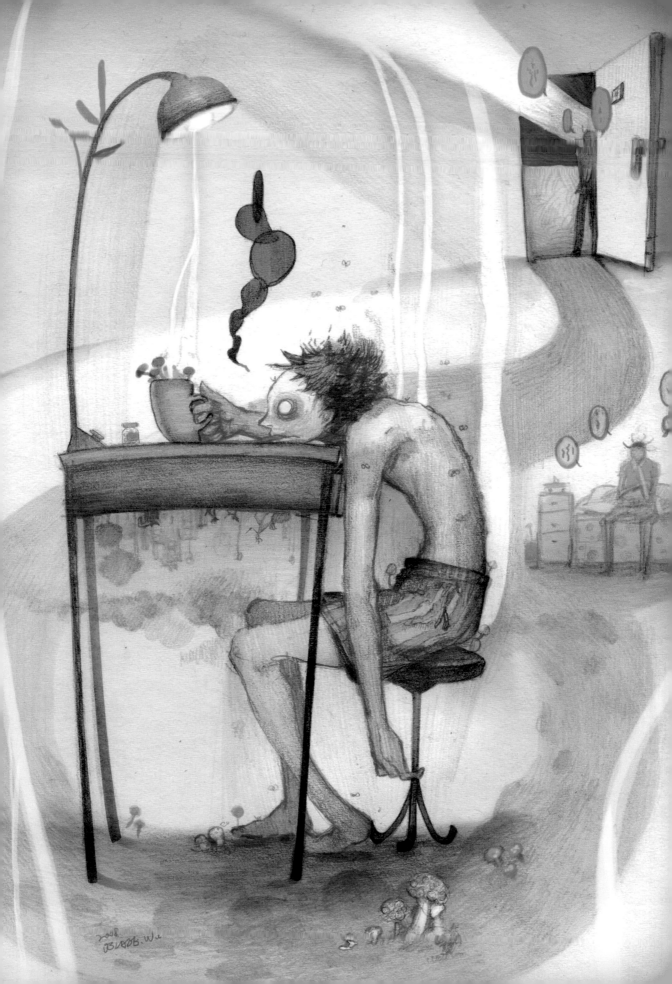

』°

救世主

The savior

2008

九把刀中篇小說〈X理論〉的插畫之一，
收錄於九把刀中短篇小說傑作選《綠色的
馬》，蓋亞出版。

Illustrated for "Xtheory", one of the short story in *The Green
Horse* by Giddens, published by Gaeabooks.

L

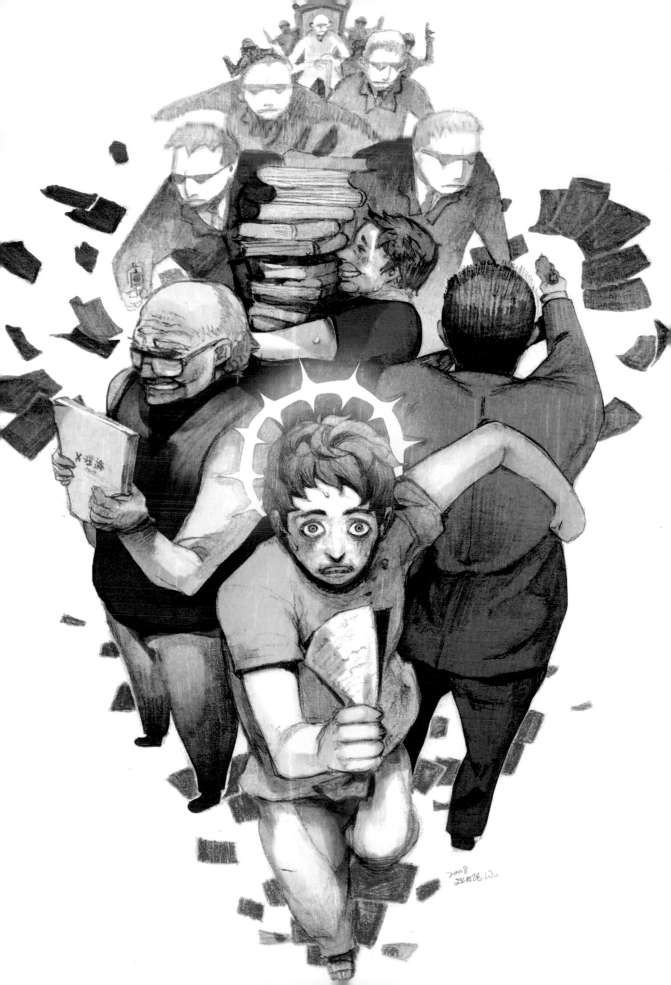

在公園和演唱會
In park and concert
2008

九把刀短篇小説〈不再相信愛情〉的插畫
之一，收錄於九把刀中短篇小説傑作選
《綠色的馬》，蓋亞出版。

Illustrated for "Fuck off love", one of the short story in *The Green Horse* by Giddens, published by Gaeabooks.

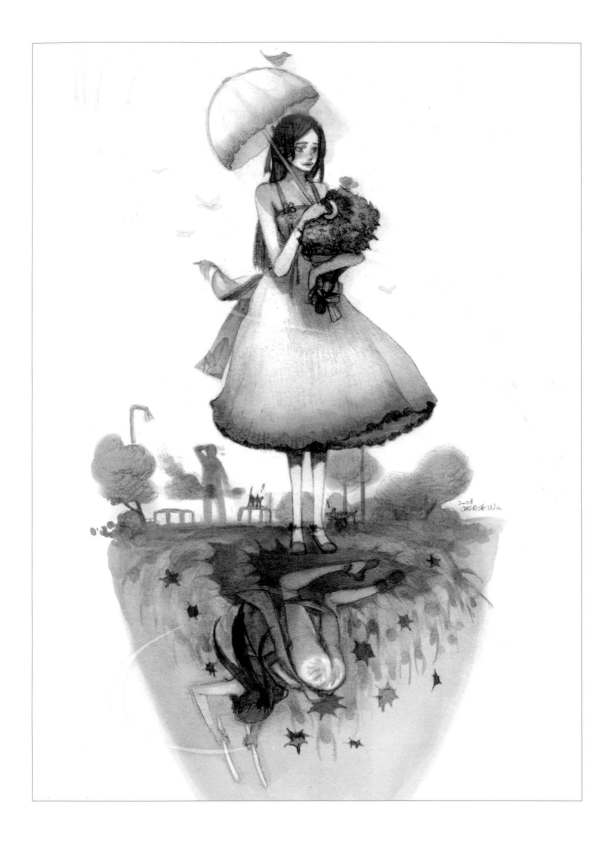

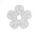

機構
Industry
2008

九把刀短篇小說〈機構〉的插畫之一，收錄於九把刀中短篇小說傑作選《綠色的馬》，蓋亞出版。

Illustrated for "Industry", one of the short story in *The Green Horse* by Giddens, published by Gaeabooks.

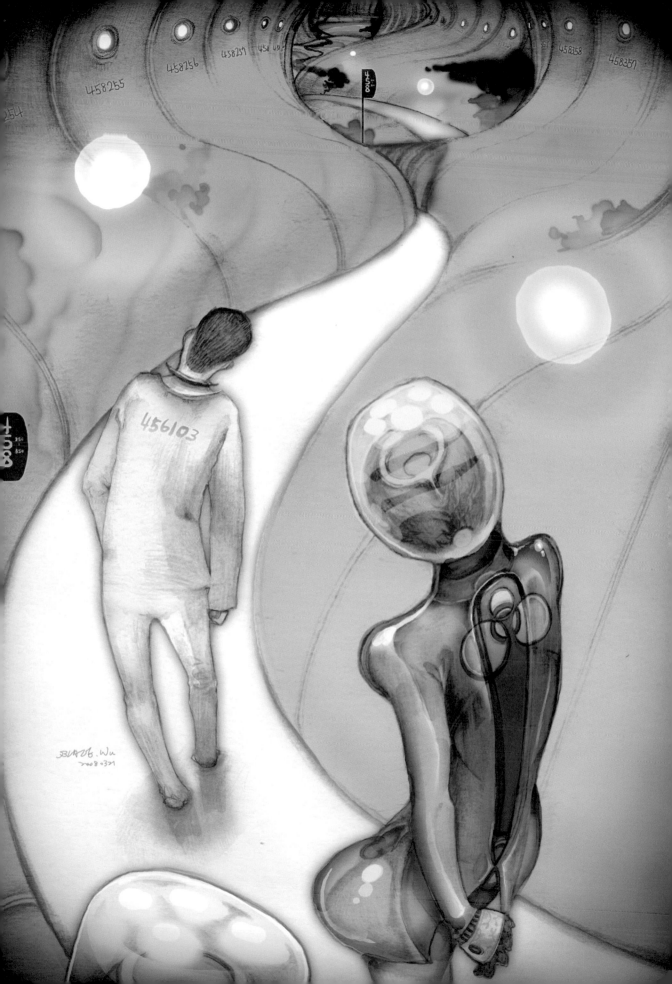

，。

等待中
Waiting

2008

九把刀中篇小說〈浮游〉的插畫之一，收
錄於九把刀中短篇小說傑作選《綠色的
馬》，蓋亞出版。

Illustrated for "Murmur", one of the short story in *The Green Horse* by Giddens, published by Gaeabooks.

在床上
On the bed
2008

九把刀短篇小説〈高潮〉的插畫之一，
收錄於九把刀中短篇小説傑作選《綠
色的馬》，蓋亞出版。

Illustrated for "High Tide", one of the short story in *The Green Horse* by Giddens, published by Gaeabooks.

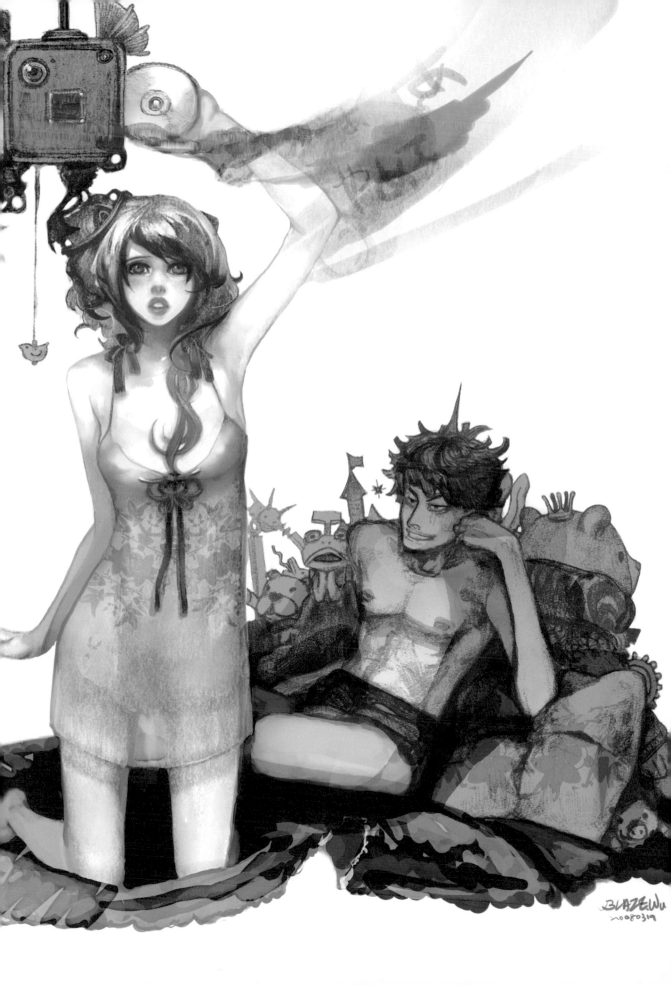

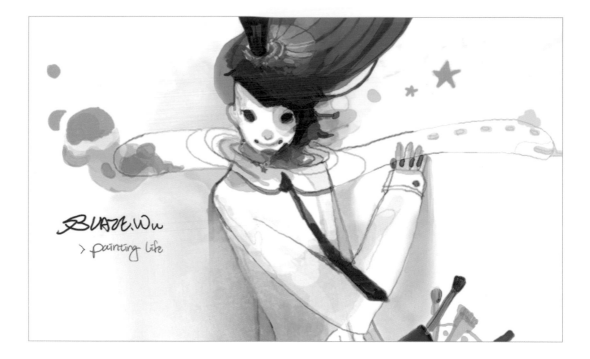

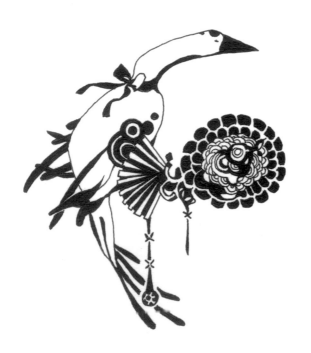

,°

繪畫生活
Painting life
2008

塗鴉之一。

One of my painting.

L

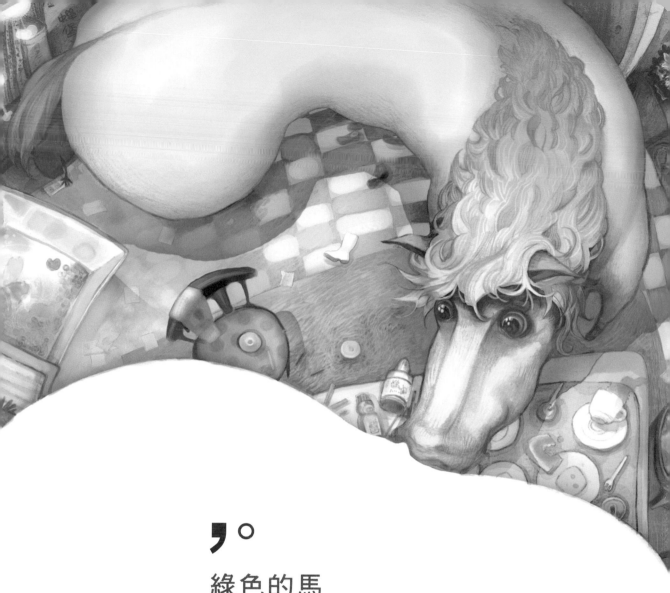

，°

綠色的馬
Green horse
2008

九把刀中篇小説〈綠色的馬〉的插畫之一，
收錄於九把刀中短篇小説傑作選《綠色的
馬》，蓋亞出版。

Illustrated for "Green Horse", one of the short story in *The Green Horse* by Giddens, published by Gaeabooks.

﹐°

不幫忙就搗蛋
Trick or help
2005

小説插畫《不幫忙就搗蛋》。
星子著，蓋亞文化出版。

Illustrated for *Trick or Help*.
A novel by Teensy, published by Gaeabooks.

L

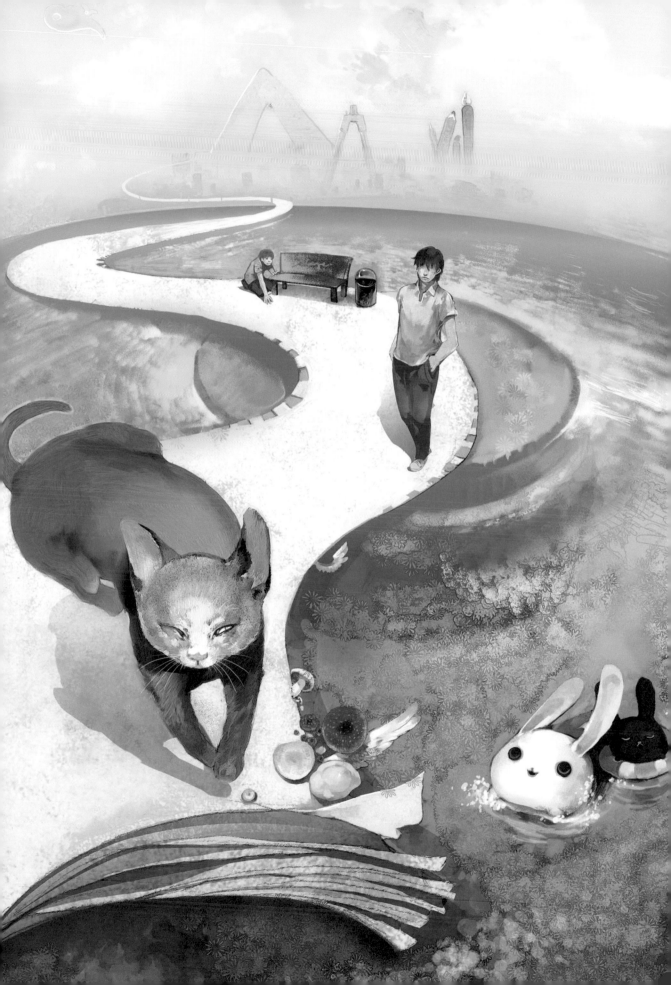

公元 6000 年異世界
6000 AD

2005

小説插畫《公元6000年異世界》。Div 著，
蓋亞文化出版。

Illustrated for *6000 AD*.
A novel by Div, published by Gaeabooks.

∟

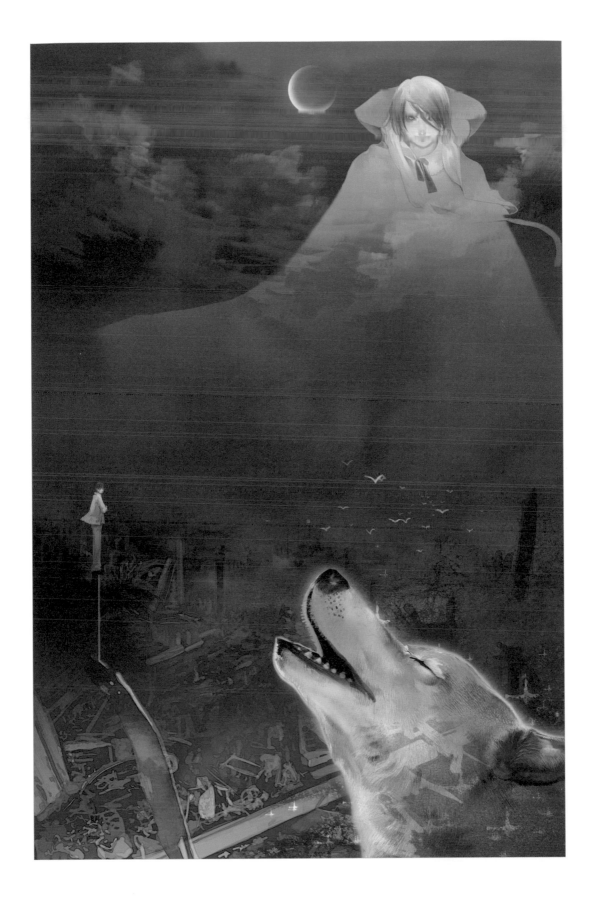

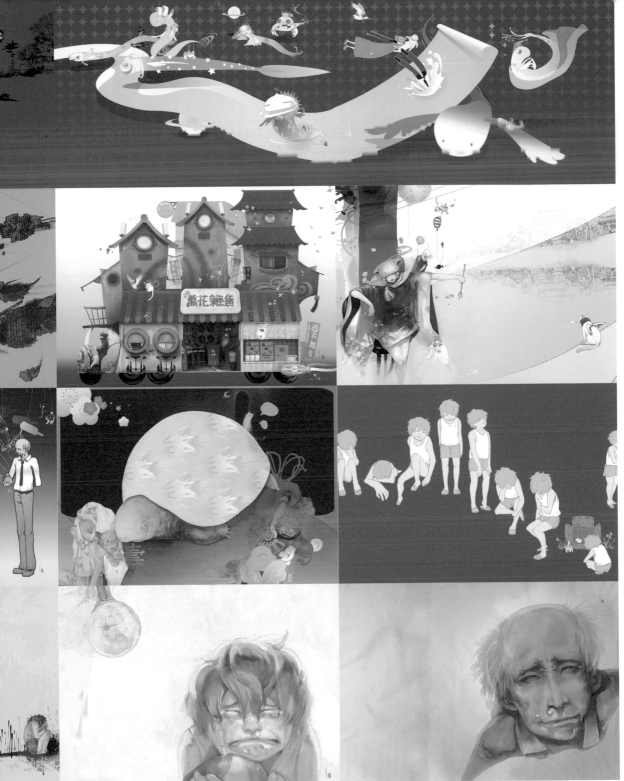

，°　萬花
Kaleidoscope
2005

大學畢業製作繪本《萬花》。

The sketchbook — *kaleidoscope*

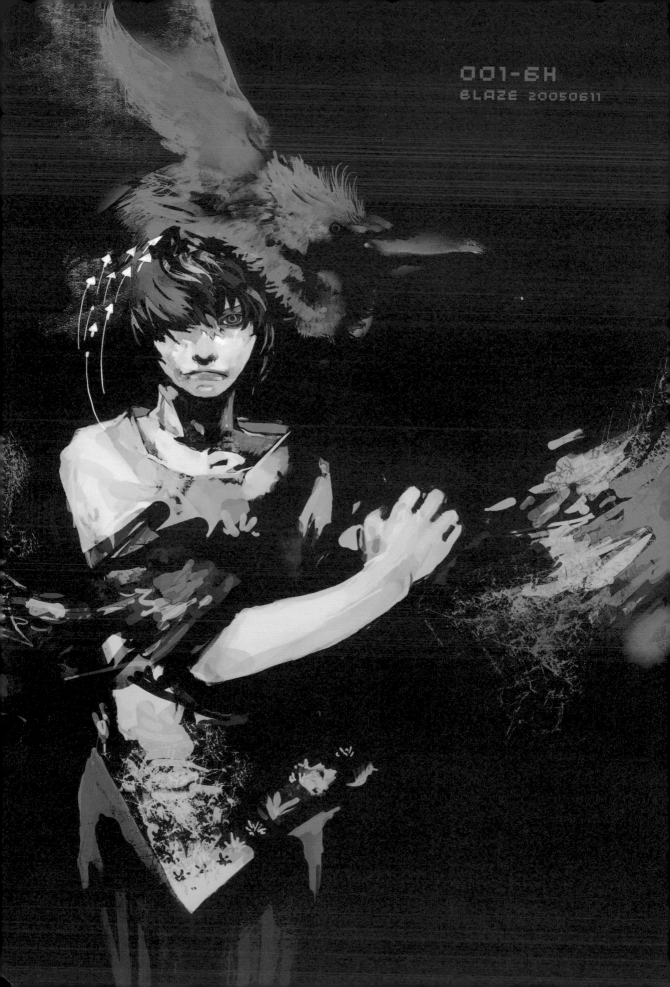

001-6H
BLAZE 20050611

，°

單手男
One-armed man
2005

一天練習畫作品之一。

One painting of the daily practices.

」

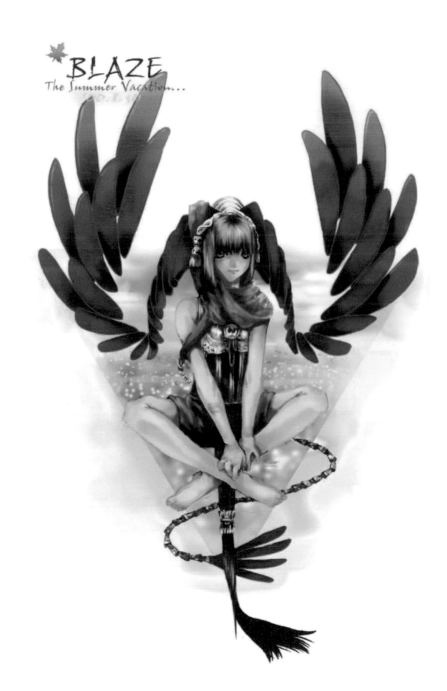

,° 暑假
Summer Vacation
2000

第三張 CG 作品。
使用軟體 photoimpact 與滑鼠。

Third CG work.
By photoimpact and mouse.

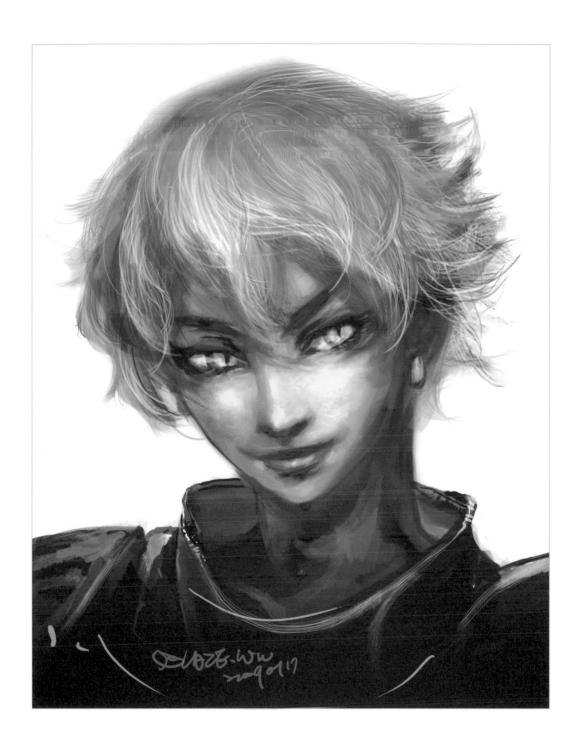

騎士
Knight
2009

似乎是混亂中立陣營的騎士。

He seems to be the knight in chaotic & neutral camp.

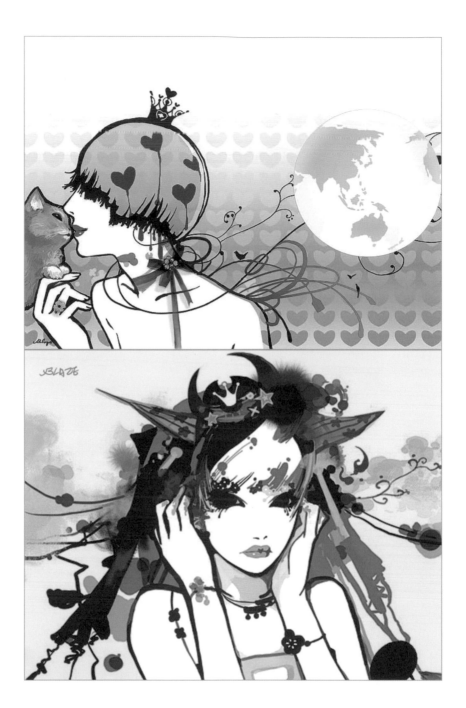

 聽
Listening
2006

傾聽世界的旋律。

Listen to the melody of world.

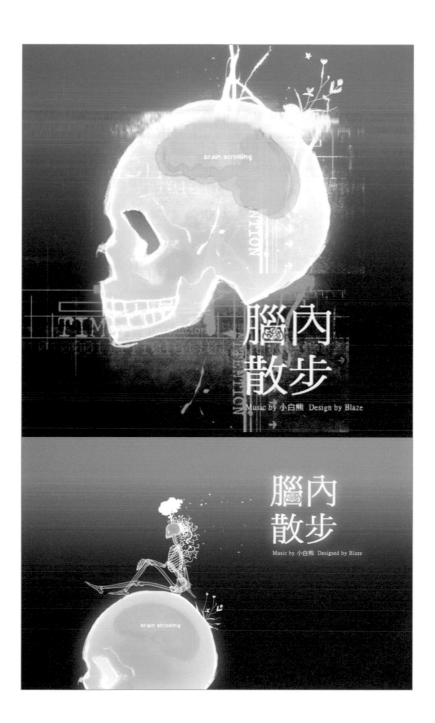

 腦內散步
Brain strolling
2006

第三屆腦天氣徵展入圍及音樂特別獎。
音樂：E-Shen　動畫：Blaze

The third session of brain weather drafts exhibition
being accepted and music special prize.
Music by E-Shen, created by Blaze.

，°　郵差
Postman
2004

中華郵政漫畫形象代言人徵選活動 - 第三名

Comic image of the Chunghwa Post Co., Ltd.
spokesmen selection activities - the third.

，。 父與子
Father and Son
2007

flash 動畫角色設計。

character design of the flash animation.

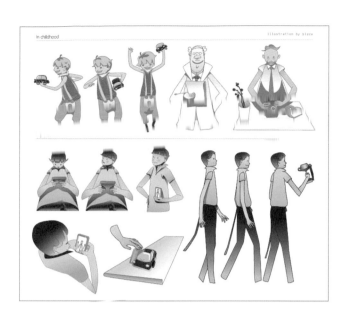

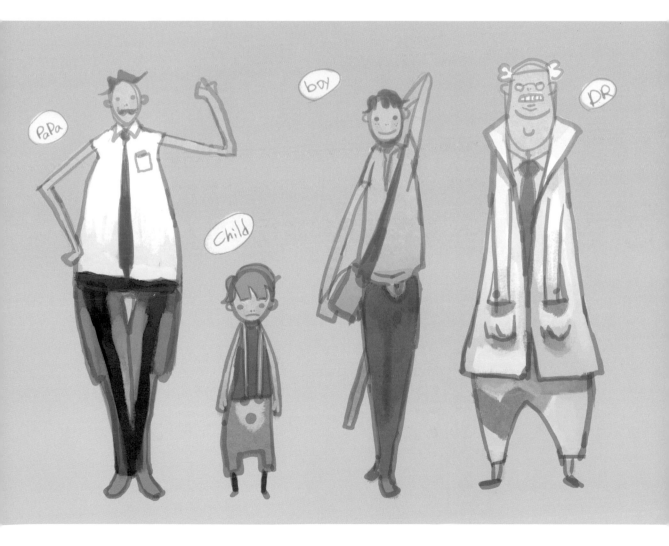

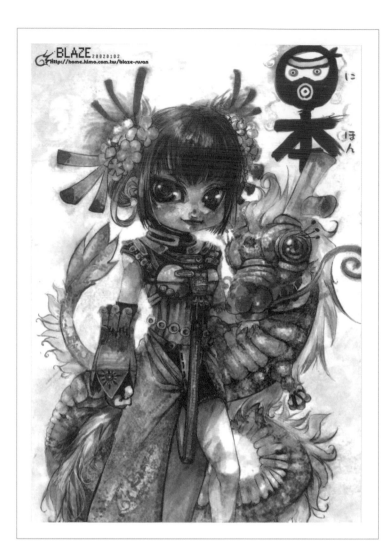

東洋少女和旅行機械人
Oriental girls and travel robot
2002

手繪作品。

Hand-painted works.

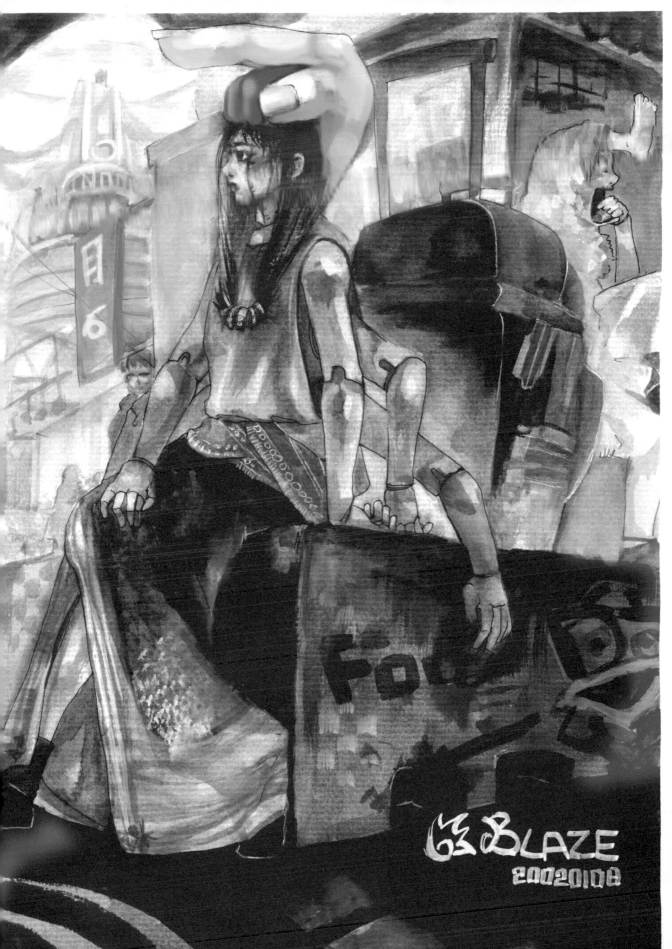

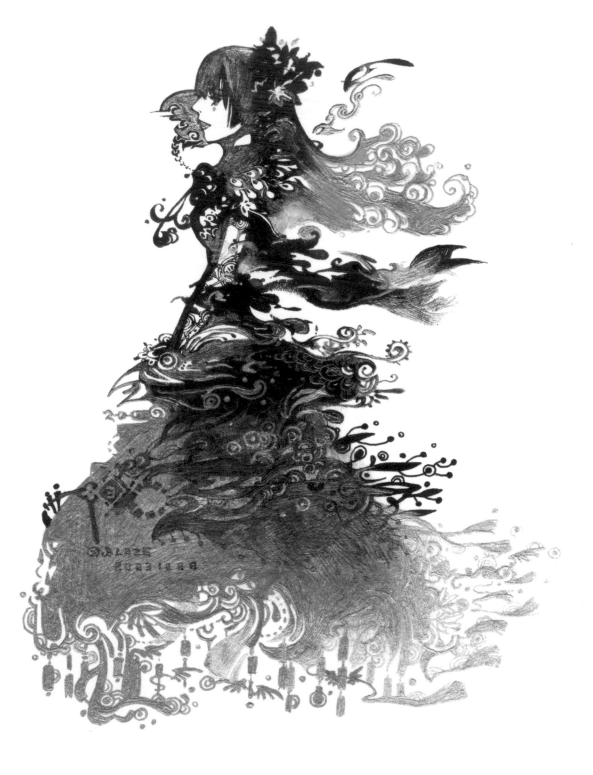

Illustration by Blaze

，。

賣花少女
Flower girl
2003

原子筆與油漆筆混合畫出的作品。

The work made by mixture of ball pen and paint pen.

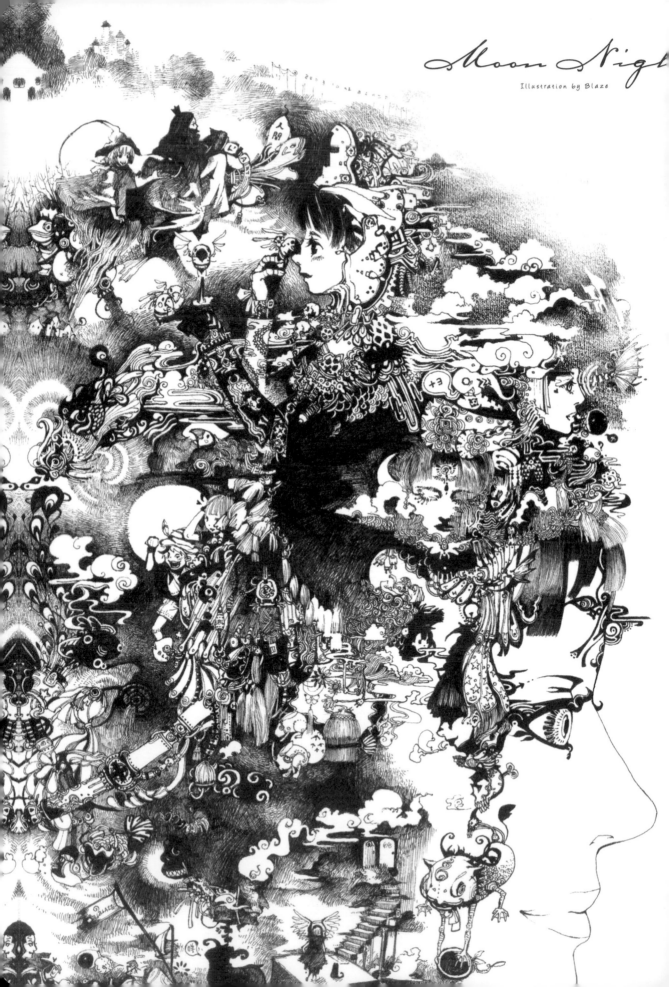

Moon Night
Illustration by Blaze

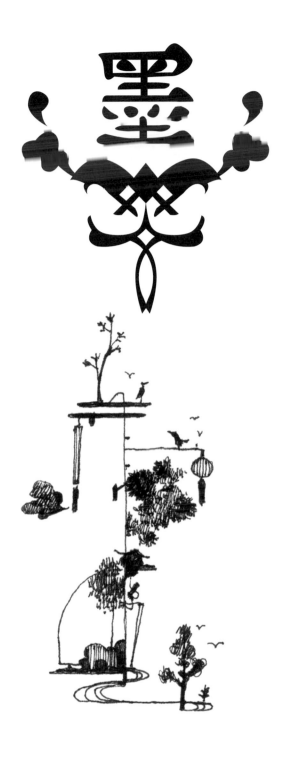

，。 線稿與概念圖
Sketch and Concept
2000-2009

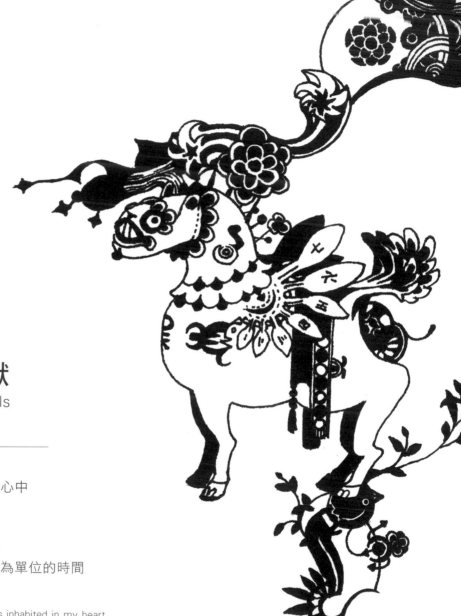

』°

星 期 獸
Weeks animals
2008

有兩隻野獸在我心中
一隻喜歡工作
一隻喜歡休息
工作時喜歡競爭
休息時喜歡和平
生活在以星期作為單位的時間

There are two beasts inhabited in my heart
One likes to work,
The other one likes to rest.
Enjoy the competition at work,
and the peace in the rest.
Living in the time of one week as per unit.

星期

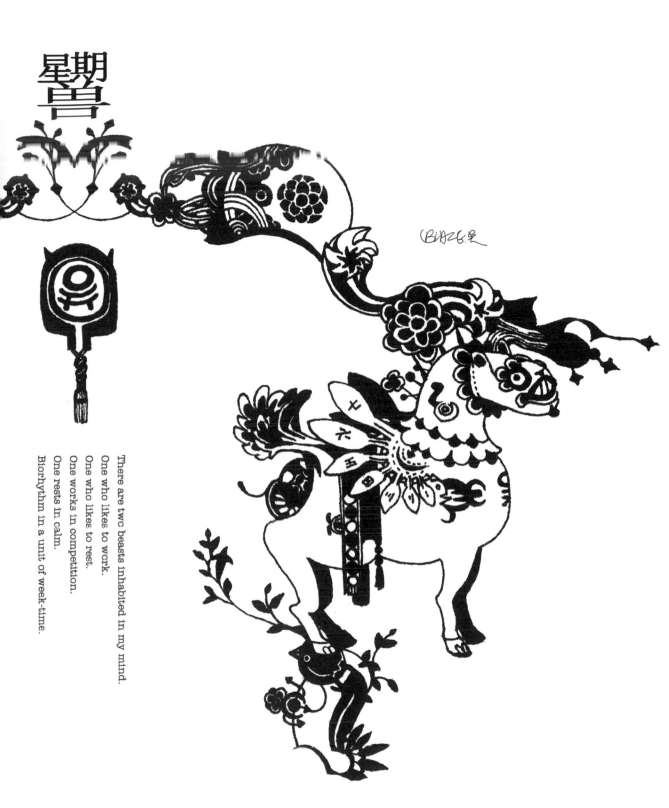

There are two beasts inhabited in my mind.
One who likes to work.
One who likes to rest.
One works in competition.
One rests in calm.
Biorhythm in a unit of week-time.

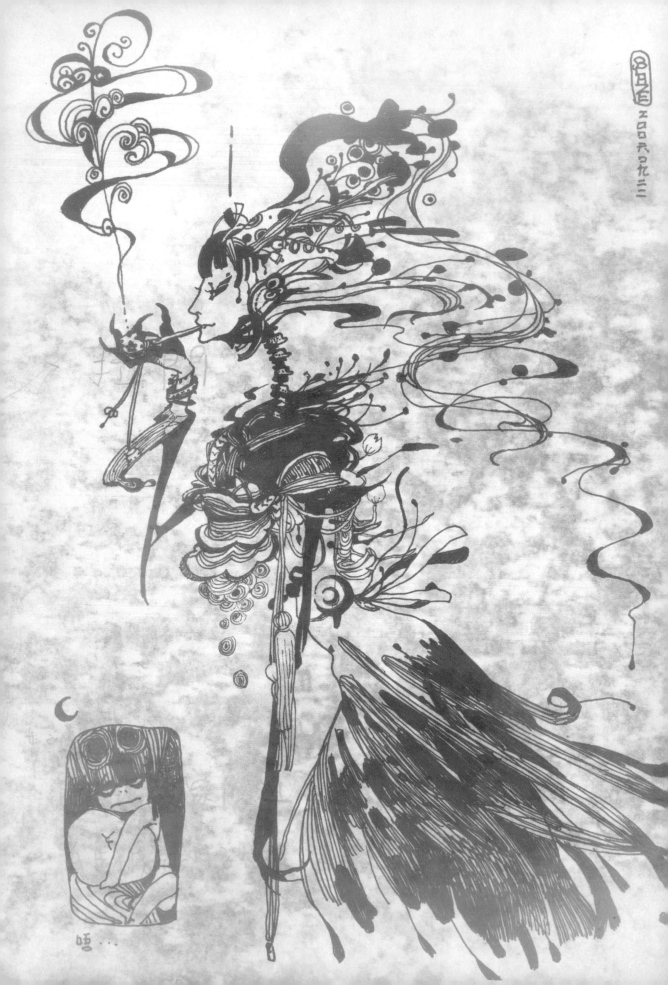

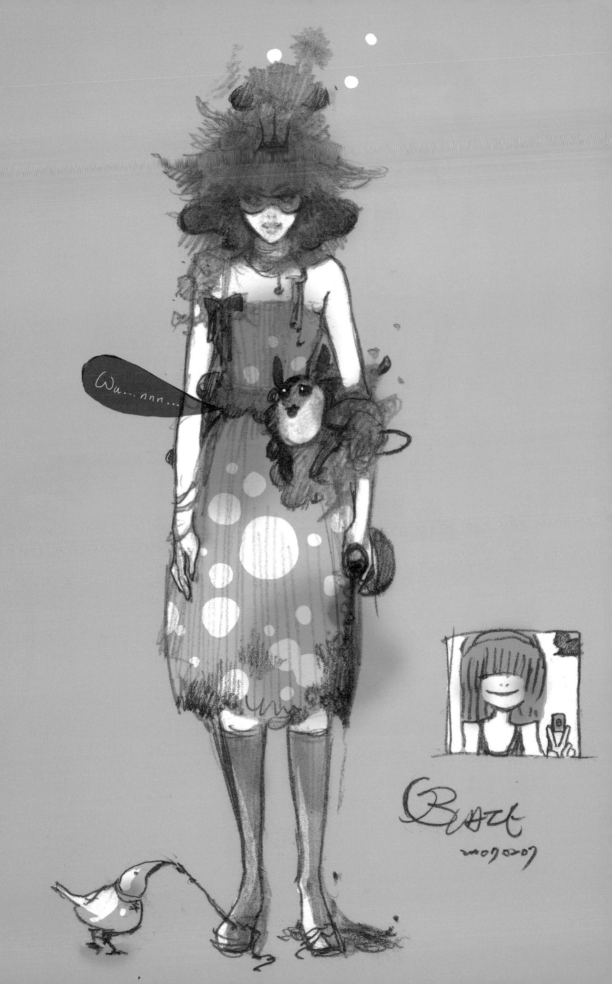

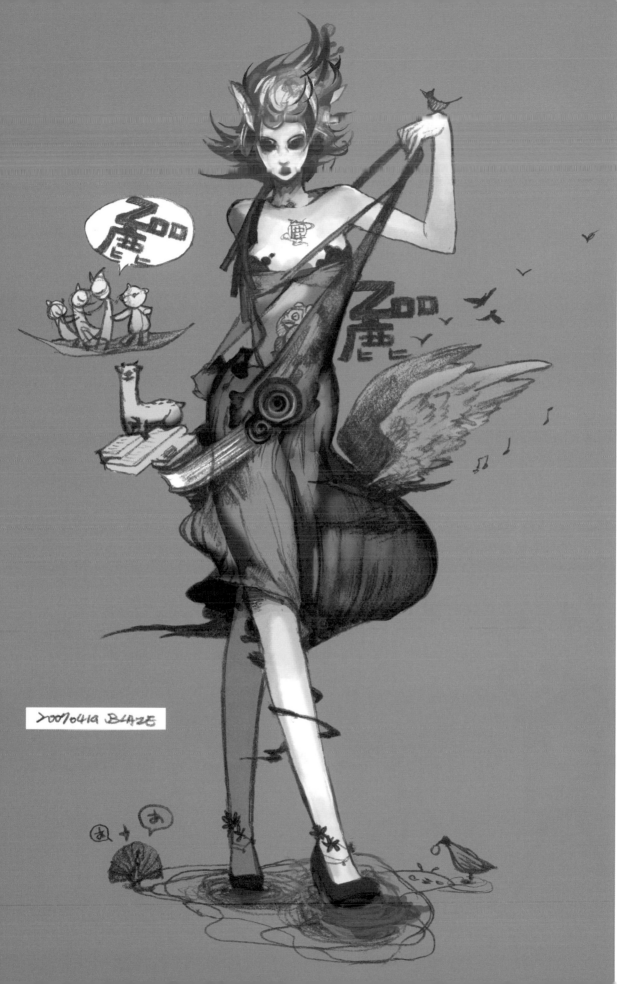

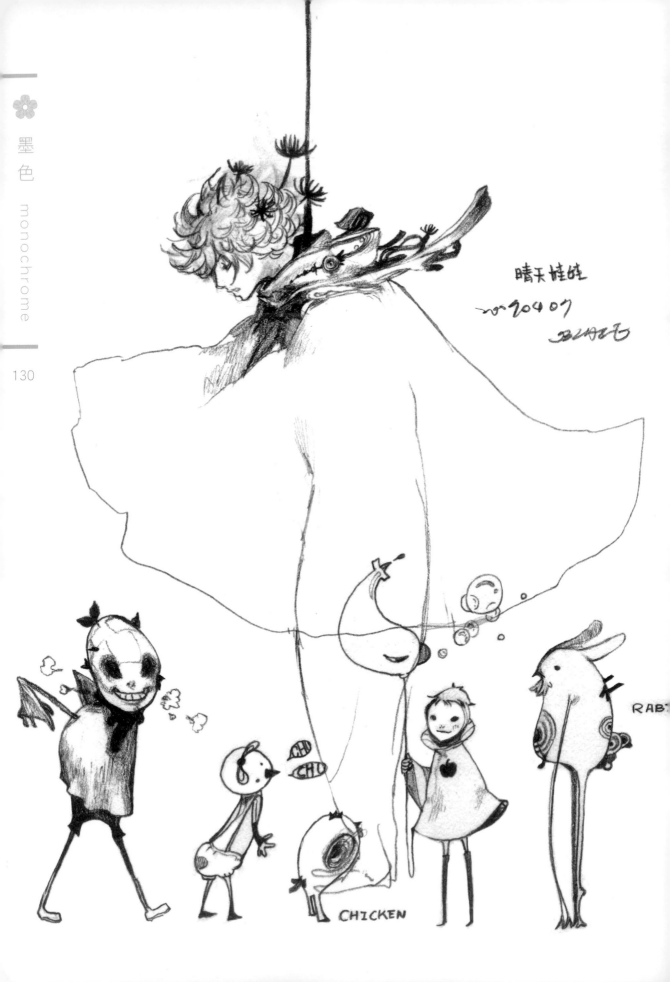

晴天娃娃

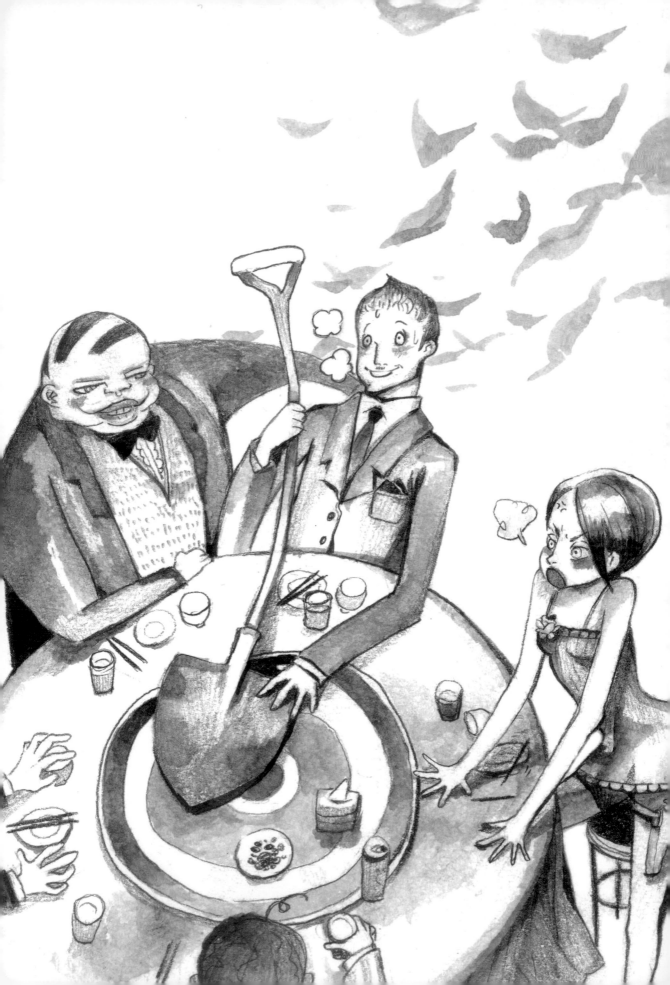

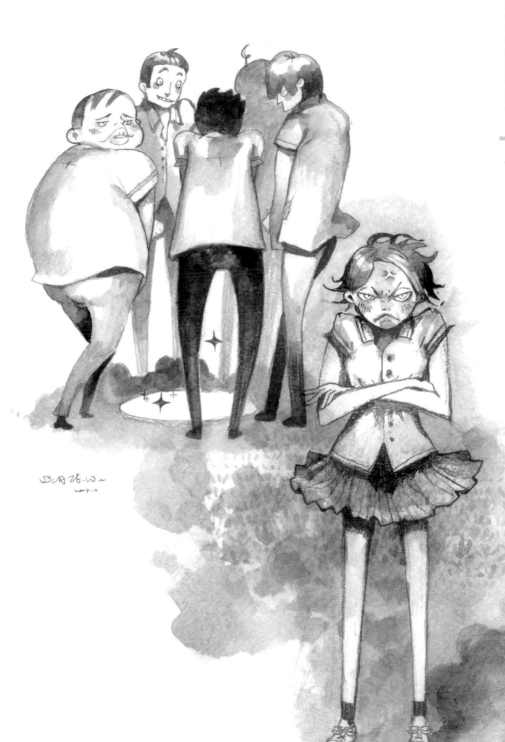

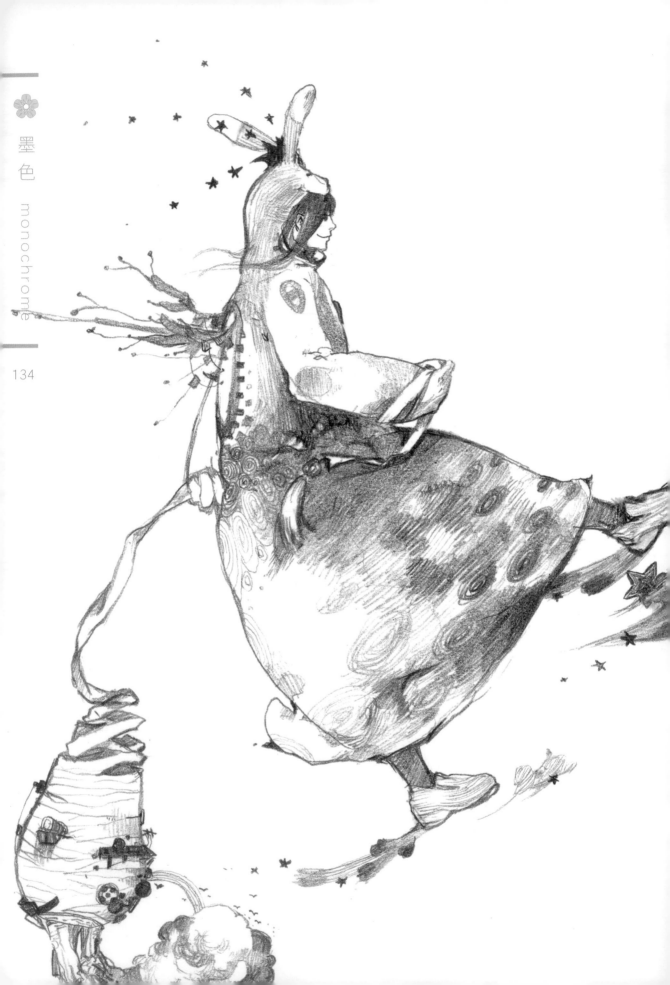

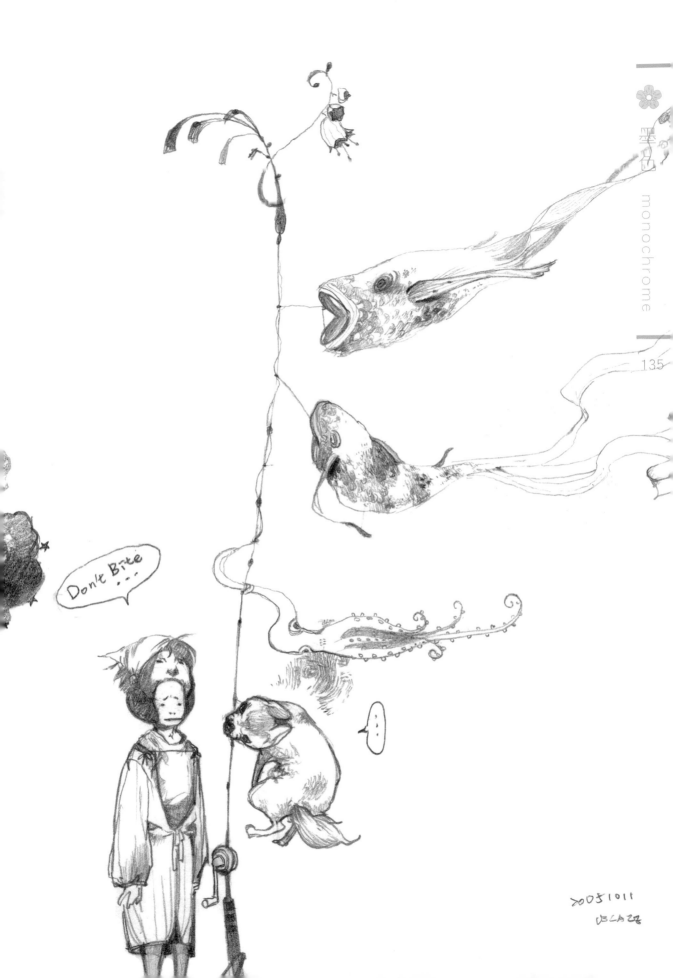

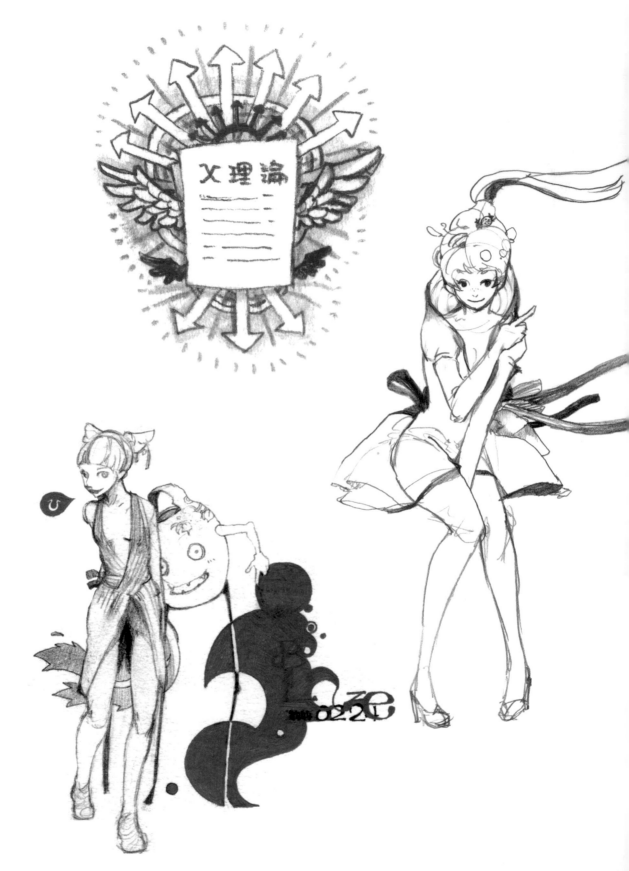

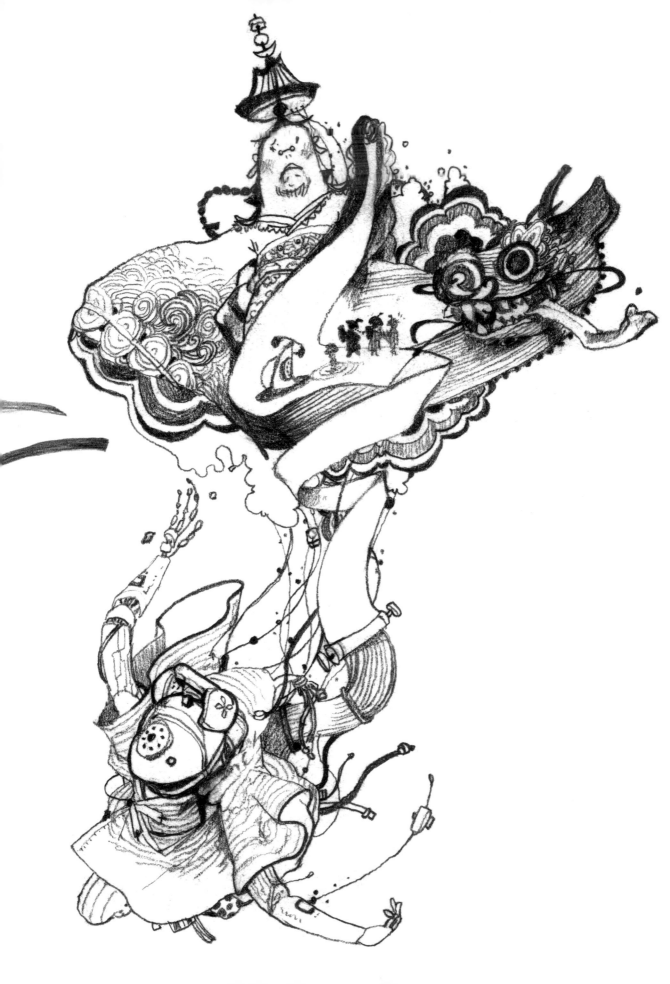

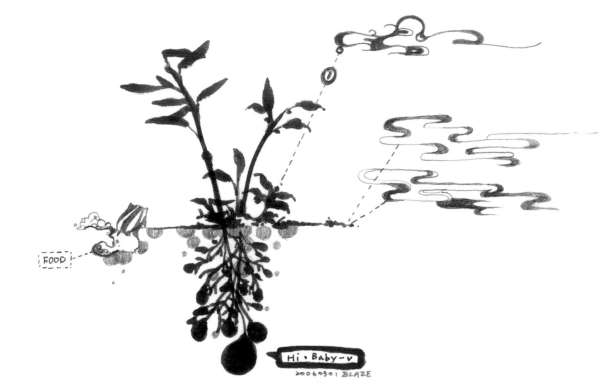

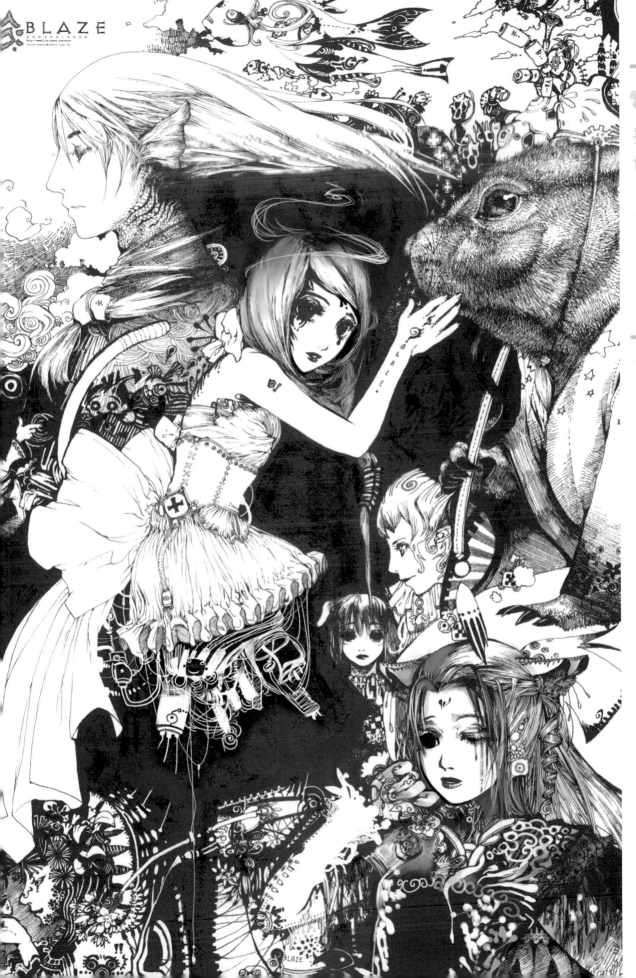

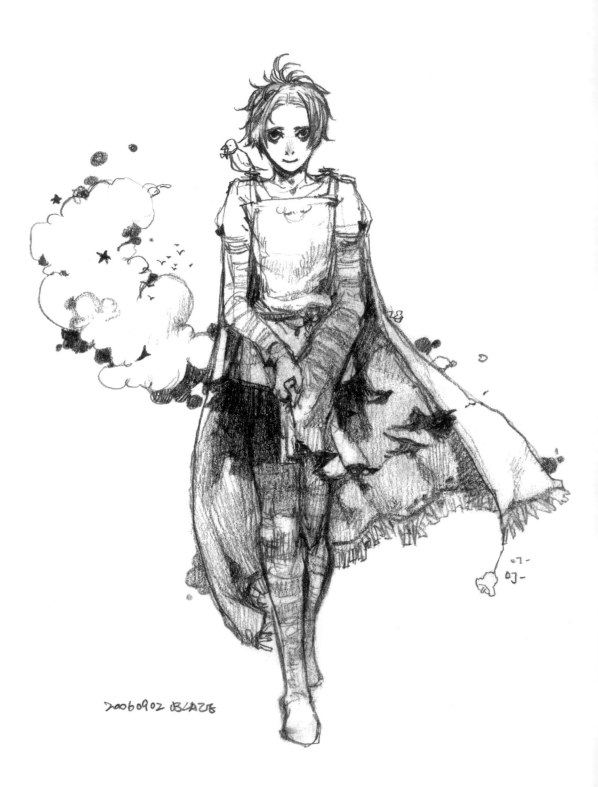

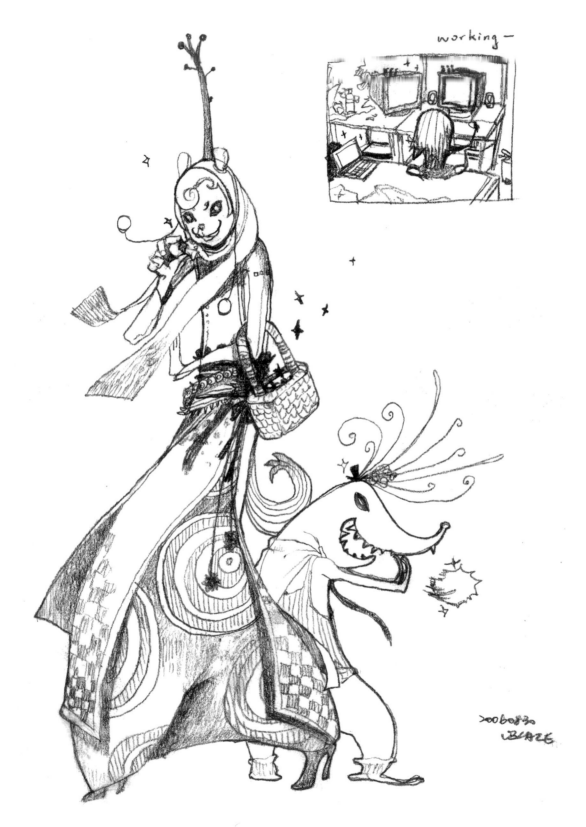

working—

20060830
BLAZE

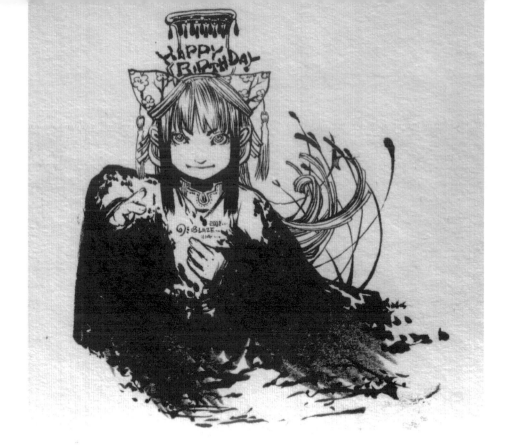

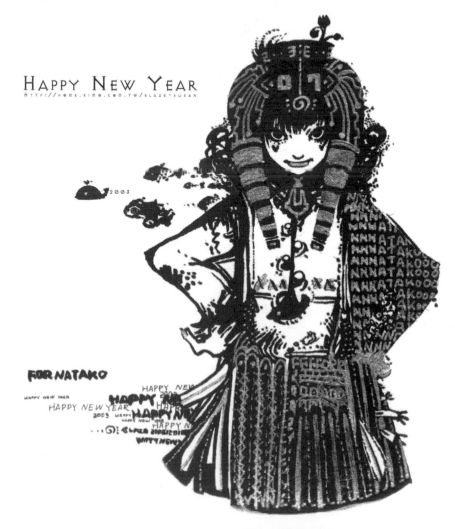

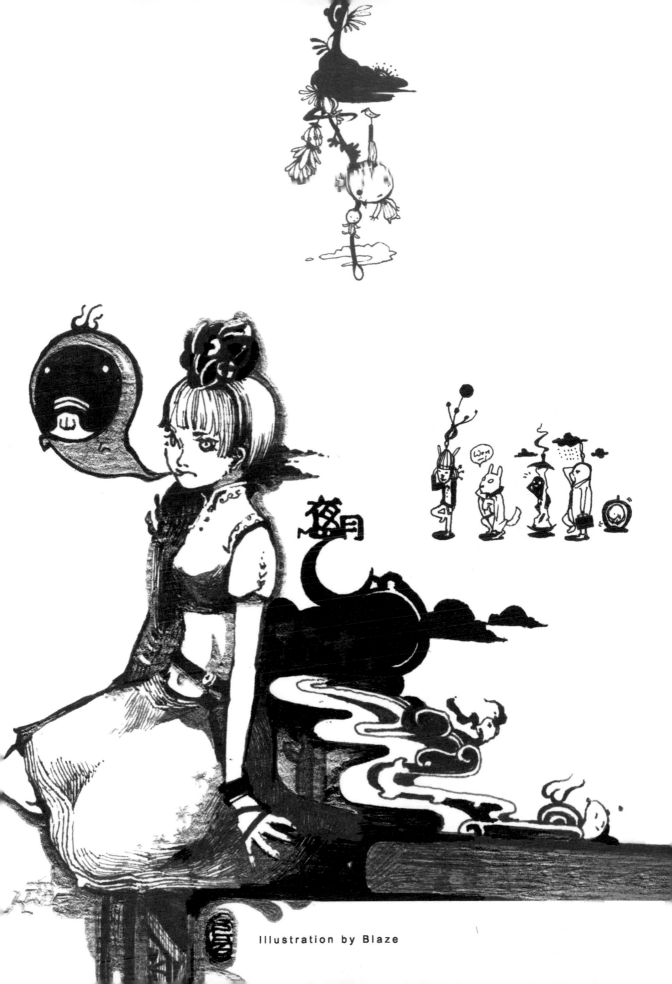

Illustration by Blaze

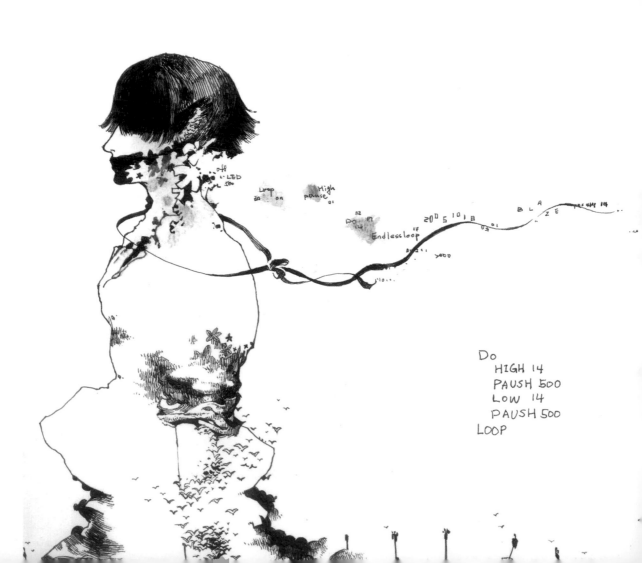

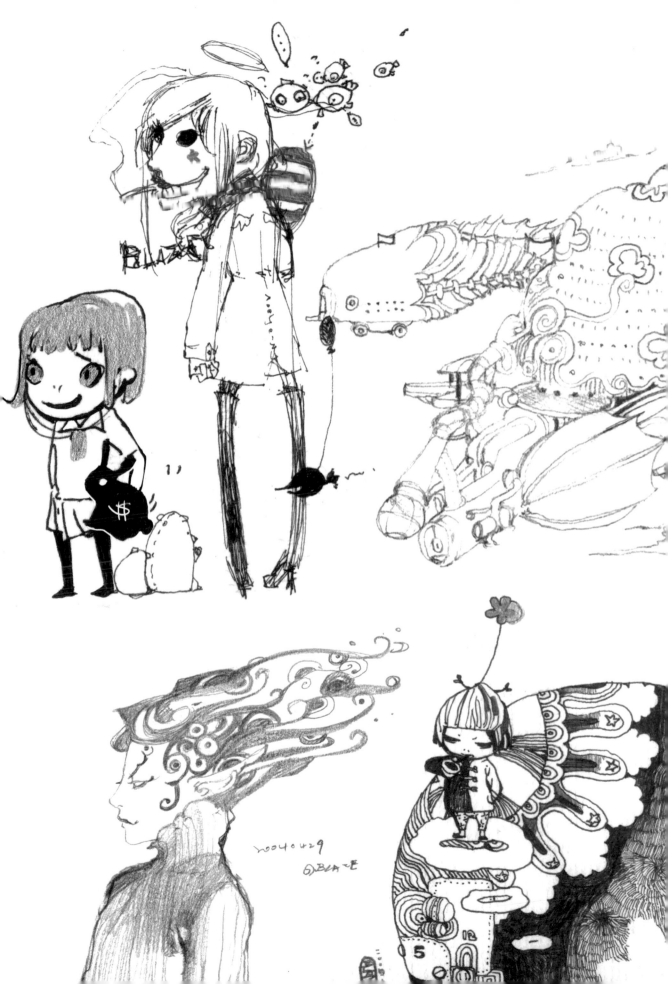

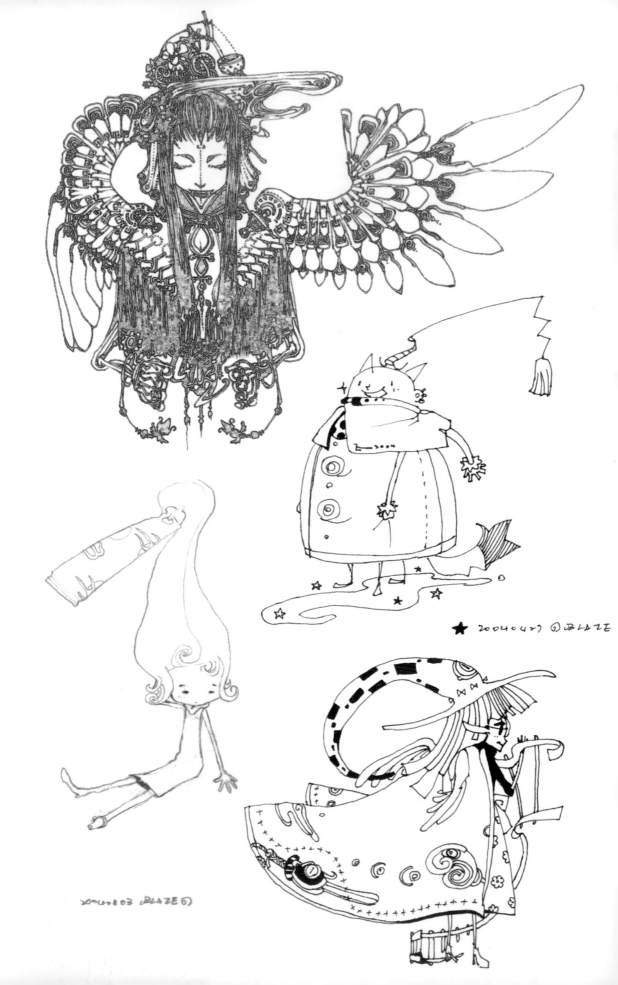

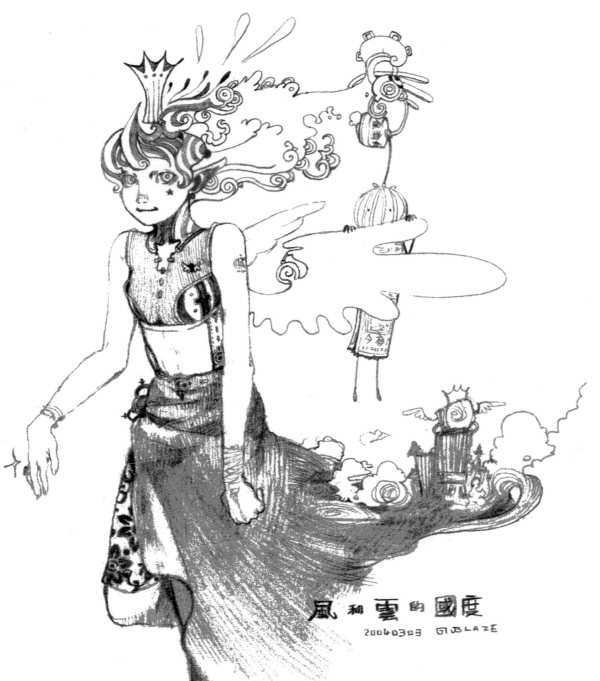

風 和 雲 的 國度
20040303 GJBLAZE

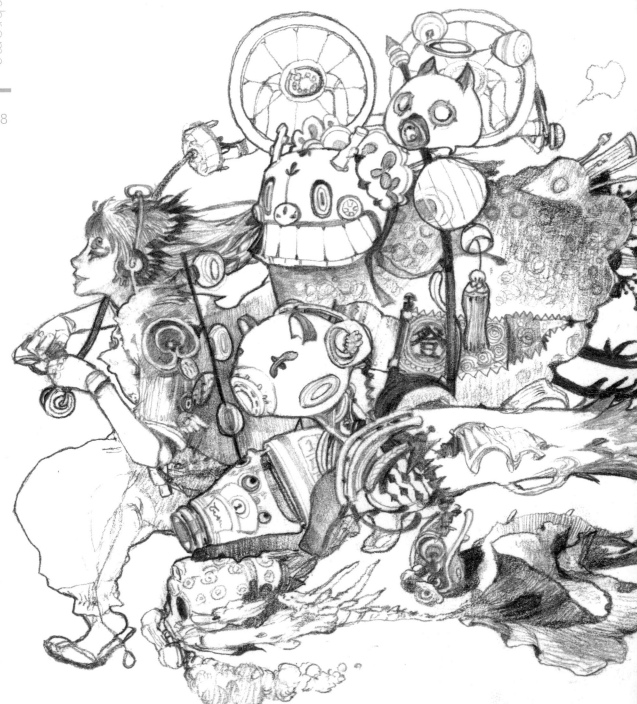

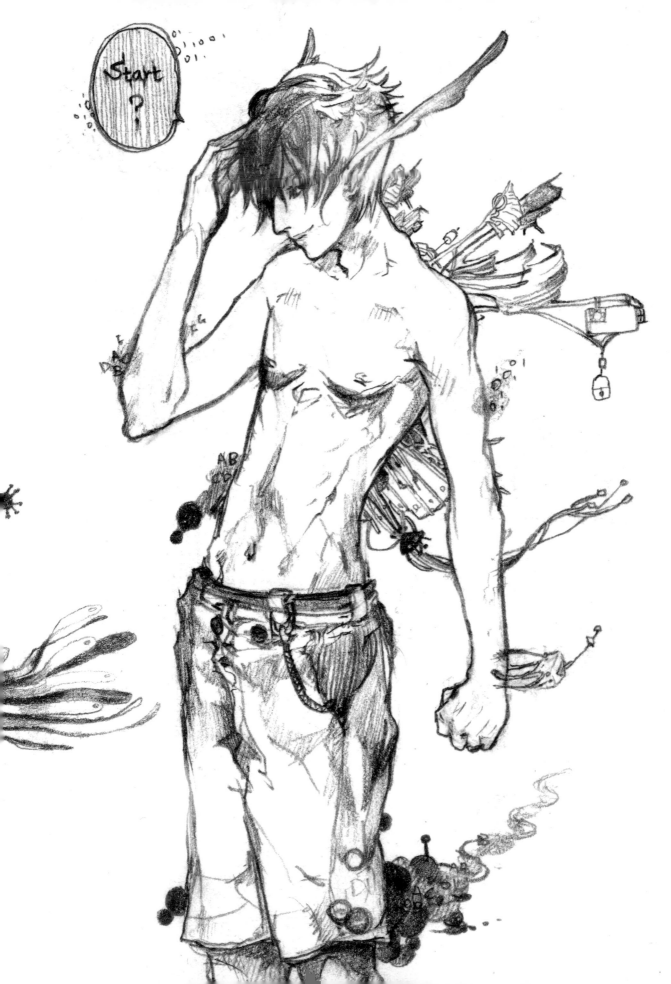

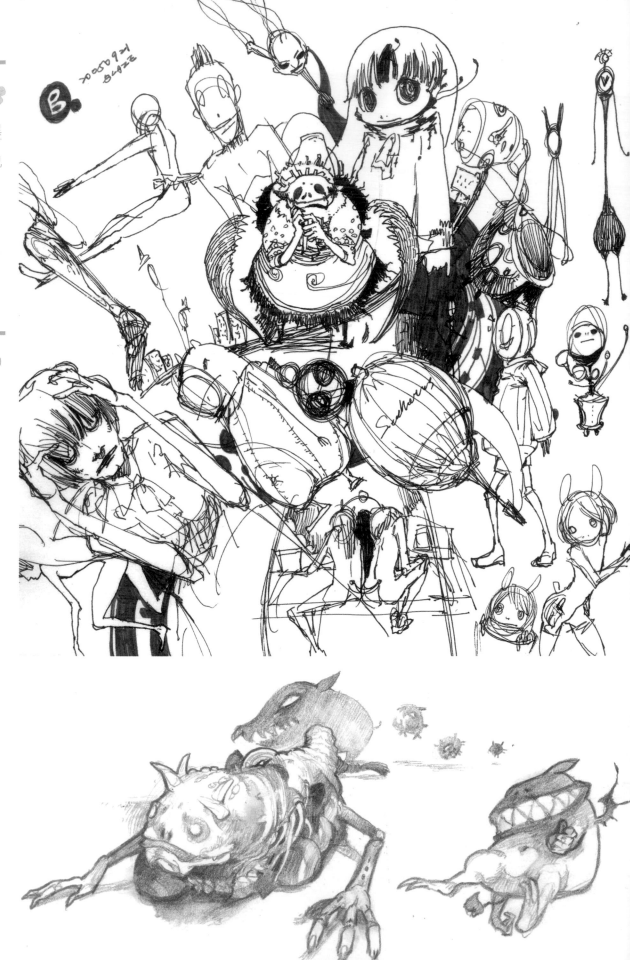

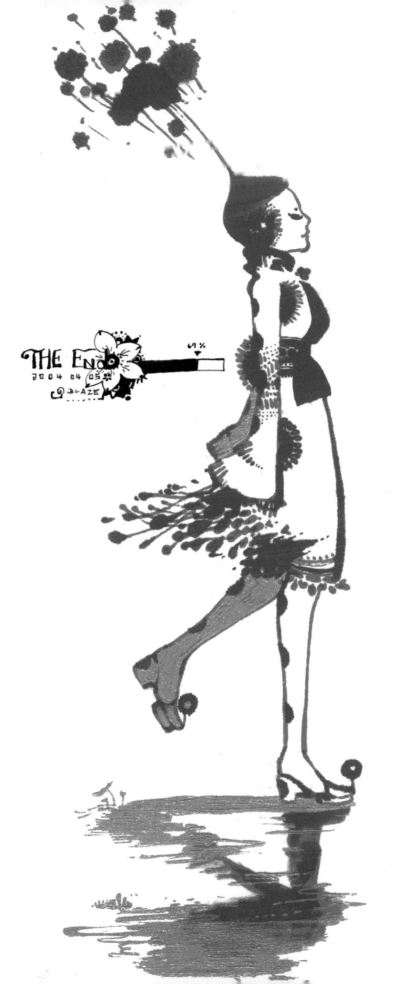

THE END
2004 04 05
BLAZE

67%

後記

創作，對我來說已經是生命的一部分了，成長過程有創作伴隨著是十分幸福的一件事。

經過兩年多的醞釀終於發行了第一本個人畫冊，收錄的圖是我開始自學數位插畫至今的作品節選，能把自己的創作脈絡作一個總整理實在令人開心。

這次畫冊感謝出版社多方面的幫忙與支持才能成功發行，邀請推薦名單都是帶給我諸多感受與影響的創作者們。其中最高興的就是能邀請到我最喜歡與敬重的作家九把刀來幫我寫序，他的故事在我大學的時候給與的樂趣還有想像總是最棒的。當我收到序，當下的心情超感動的，刀老大你寫小說以外的文章怎麼也都那麼有力量啊。

同時謝謝大家的啟蒙繪師 VOFAN 熱情推薦，在自學電繪之初，我也從他的網路教學受益良多。Nylas 的音樂一直是工作時的最佳伴侶，不管是音樂還是圖文書都是充滿著溫暖又特別的氛圍，能請到腊筆寫推薦是一件很棒的事。最後陶亞倫老師與史明輝老師願意幫我推薦，對我而言真的是很大很大的鼓勵。

還有很多很多想要感謝的人，包括家人、朋友、老師、網友以及正在讀這段文字的各位，真的是有說不出的感恩與溫暖在心頭。

其他我想傳達的都在作品裡了，謝謝你們！

BLAZE.Wu

＇ ○ Afterword

Creation for me, has become the part of my life. It's a bliss that design has accompanied at my phase of growing up.

After two years' arrangement, finally I published my own collections that collected the works from learning computer aid graphic design by myself at the beginning to the latest works which is a very thrilling things to sort my works by this chance.

I want to show my highest appreciation to the publishers that without their supports and help, this collection won't be published successfully. It's also my honor that my favorite and respected novelist - Giddens can write foreword for my collection. The enjoyments and imagination brought from Giddens' novels always fulfill my life.

At the same time, I want to express my gratitude to VOFAN's strongly recommendation. I have got inspiration from him when I started learning computer aid graphic design. The Nylas music has been time the work best companion, no matter is music or attempts the copy clerks to fill warm the special atmosphere, can welcome write the recommendation to the sacrificial pen is a very good matter. Finally thank for professor Tao Yalun and professor Shi Minghui, what as recommendation concerns me is really very greatly very big encouragement.

There are so many people that I want to thank for: my family, friends, teachers, net pal and people who is reading this. There's so much gratitude that beyond the words.

What I want to express are showed on my collection, please enjoy it and thanks for reading this!

BLAZE.Wu

Blaze Wu

| 學歷 |

國立台北藝術大學新媒體藝術研究所
環球技術學院視覺傳達設計系

| 工作經歷 |

2009 蓋亞文化「熾熱之夢」George R. R. Martin 小說封面插畫。
2009 春天出版社「龍族Ⅱ」李榮道小說封面插畫。
2008 蓋亞文化「後青春期的詩」九把刀與五月天同名創作小說內頁插畫。
2008 春天出版社「拼命去死」九把刀小說內頁插畫。
2008 蓋亞文化「影子瀑布」賽門・葛林作品封面插畫。
2008 《我們只是蘋果皮》誠品好讀 issue84「獨立樂團專輯設計」受訪。
2008 蓋亞文化「綠色的馬」九把刀短篇小說內頁插畫。
2008 春天出版社「龍族」第一部系列封面繪製。
2007 《聽見斯德哥爾摩》北歐合輯專輯設計，默契音樂發行。
2007 參與國科會「2007 科學季 - 科技台灣驚嘆號」互動裝置動畫製作，並於中正紀念堂展出。
2007 小白熊電台《我們只是蘋果皮》EP 設計與繪製，默契音樂發行。
2007 《Cake on Cake》北歐樂團專輯封面繪製，默契音樂代理發行。
2006 蓋亞文化「永夜之城 Nightside」系列封面繪製。
2006 春天出版社「退魔錄」系列封面繪製。
2006 《CG SMART》vol.2 封面教學製作，碁峰出版。
2005 參與夜貓館咖啡屋《BOPEEP》vol.1 孩子們的秘密基地製作。
2005 蓋亞文化「符文之子Ⅱ - 德莫尼克」系列封面繪製。
2005 春天出版社「地獄列車」書封面繪製。
2005 蓋亞文化「公元 6000 年異世界」書封面繪製。
2005 春天出版社「少林寺第八銅人」九把刀小說封面繪製。
2005 受邀參加日本飛鳥新社「ss」雜誌內頁跨頁插畫繪製。
2005 蓋亞文化「不幫忙就搗蛋」書封面繪製。
2004 與夕月、VOFAN 合作出版繪本《德律風少女進化論》。
2003 蓋亞文化「都市妖奇談」書封面繪製與人物設定。
2003 參與日本 IDEA FACTORY 發行的 PS2 遊戲「Cardinal Arc ～混沌的封牌～」魔法牌繪製。
2002 擔任智冠科技 -「紙牌遊戲 - 中國魔法牌 - 特約畫家」。

| 得獎經歷 |

2007　「愉悅」‧互動裝置，「2007KT 科藝獎互動科技組」銀獎，
　　　「第二屆台北數位藝術獎」入圍。

2006　「腦內散步」與音樂創作人－陳奕璇合作作品，
　　　第三屆腦天氣徵展入圍及音樂特別獎。

2006　參與「e 化互動式資訊面板指引系統」計劃案，
　　　作品入圍－國科會「2006 KT 技藝術獎比賽」的「網路內容組」。

2005　奇幻基金會主辦 「2004 第一屆奇幻藝術獎 - 白虎獎 - 佳作」。

2004　第 13 屆時報廣告金犢獎 - 平面廣告類 - 大專組 - 化妝品項 - 入圍。

2004　中華郵政主辦 「中華郵政漫畫形象代言人徵選活動 - 第三名」。

2003　dpi 設計流行創意雜誌「2003 三月份封面夢幻馬戲團設計比賽 - 優選」。

2002　十乾科技與巴哈姆特主辦 「yes 封神榜 - 神來之筆大賽 - 金賞」。

2002　遊戲代理發行商 EA 舉辦，「無限傳說‧插畫比賽 - 優選第一名」。

2000　桃園縣政府主辦，「學生美術比賽 - 西畫類高中職普通科組 - 佳作」。

2000　行政院勞委會職業訓練局和台灣新生報社主辦「e 世代 - 網頁 SHOW- 高中組 - 佳作」。

2000　資訊月全國電腦技能競賽 - 全國校青個人組 - 網站創意 - 優等。

| 展覽經歷 |

2009　《10^{26-17}》十年軌跡插畫個展，AURA Caf，台北。

2009　《CG Excellence 2009》聯展，展出數位插畫作品『Devil's Garden』，新加坡。

2009　《消失中的慶典》主題創作聯展，AURA Caf，台北。

2009　《衡溫》數位藝術聯展，國立台灣美術館 - 數位藝術方舟。

2009　《台灣製造 - 新秀動漫藝術》聯展，台東美術館。

2008　《{ outside blaze, inner light }》插畫個展，元智大學 Museum Caf。

2007　《第二屆台北數位藝術節》數位藝術聯展，西門町紅樓，台北。

2007　《OH!》聯展於竹圍工作室十二柱 12 Bamboos。

2006　《AX2006》聯展，Gnome International Inc. 公司邀展，美國。

2006　《南海啥聲祭》參與聲音藝術演出。i/O SoundLab. Recorderz 主辦、南海藝廊協辦。

2006　國際書展夜貓館咖啡屋聯合畫展。

2006　與音樂創作人－陳奕璇參與 2006 腦天氣影音藝術祭演出。

2005　《BOPEEP vol.1 孩子們的秘密基地》夜貓館咖啡屋聯展，晴天咖啡屋，台北。

2004　參加雲林科技大學主辦之「泛太平洋技職青年設計師設計作品聯展」及「設計交流研習營」。

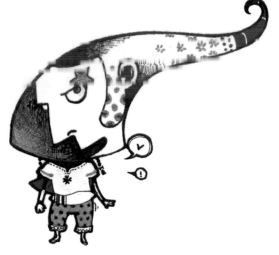

致謝
Special Thanks

我最愛的家人，

蓋亞文化，九把刀，VOFAN，Nylas 腊筆，陶亞倫老師，史明
輝老師，王穗芬老師，林純慧老師，葉于雅老師，

台北藝術大學科技藝術研究所，夜貓館咖啡屋，春天出版社，

張菁紋，張鳳詩，陳奕璇，與親愛的網友和讀者們。

特別感謝幫我校稿的編輯育如，讓我感受到職業編輯那威猛
的能力。

如果沒有您們的支持，這本畫冊是出不來的，請容我在畫冊
的最後獻上對您的感謝，您們的幫忙我一直謹記在心。謝謝
您們。

畫話本 002

吳布雷茲・十年 The Art of Blaze Wu

作者／Blaze Wu

設計／Blaze Wu

出版／蓋亞文化有限公司

　　　地址◎台北市103赤峰街41巷7號1樓

　　　電話◎（02）25585438　　傳眞◎（02）25585439

　　　網址◎www.gaeabooks.com.tw

　　　部落格◎gaeabooks.pixnet.net/blog

　　　電子信箱◎gaea@gaeabooks.com.tw

　　　投稿信箱◎editor@gaeabooks.com.tw

　　　郵撥帳號◎19769541　　戶名：蓋亞文化有限公司

法律顧問／義正國際法律事務所

總經銷／聯合發行股份有限公司

　　　地址◎新北市新店區寶橋路二三五巷六弄六號二樓

　　　電話◎（02）29178022　　傳眞◎（02）29156275

港澳地區／一代匯集

　　　電話◎（852）27838102　　傳眞◎（852）23960050

　　　地址◎九龍旺角塘尾道64號龍駒企業大廈10樓B&D室

初版四刷／2014年12月

定價／新台幣 480 元

Printed in Taiwan

國家圖書館出版品預行編目資料

吳小鼠 [十 4] Blaze Wu 作.
──初版.──台北市：蓋亞文化，2009. 07
面； 公分. --(畫話本；2)

ISBN 978-986-6473-28-9 (平裝)

1. 插畫 2. 畫冊

947.45 98010513

吴布雷兹
Wu, BLAZE